AN ARTIST'S JOURNEY

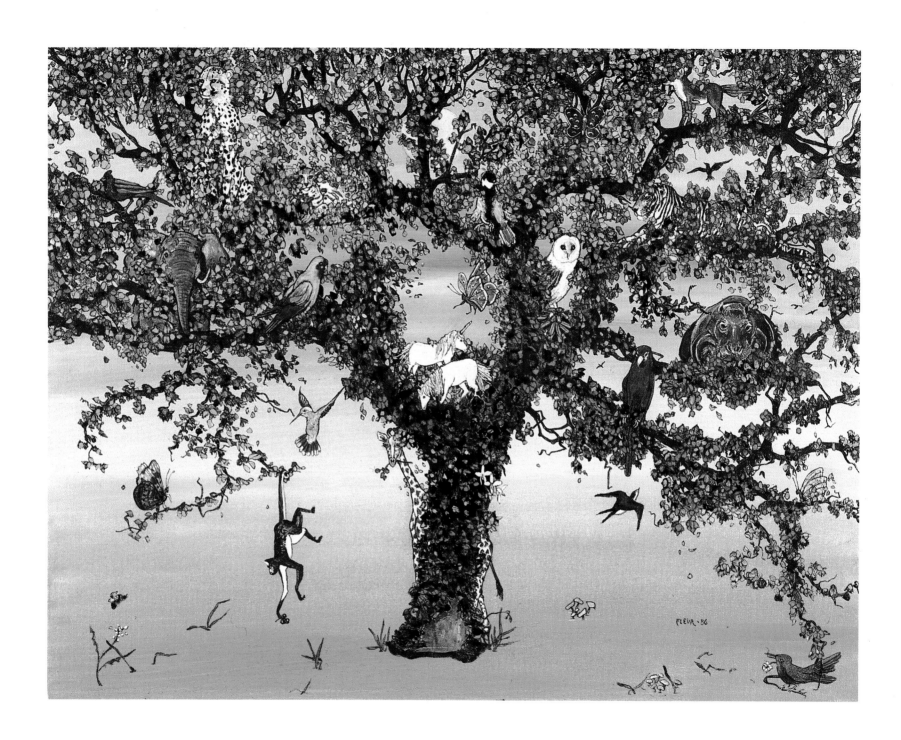

FLEUR COWLES

AN ARTIST'S JOURNEY

COLLINS
8 Grafton Street, London W1
1988

William Collins Sons & Co. Ltd
London · Glasgow · Sydney · Auckland
Toronto · Johannesburg

BRITISH LIBRARY CATALOGUING IN PUBLICATION DATA

Cowles, Fleur
 An Artist's Journey.
 1. Paintings. Special subjects. Flowers, animals
 I. Title
 758'.42

ISBN 0-00-215083-2

First published in Great Britain 1988

Copyright © Creative Industries 1988

Photoset in Linotron Old Style by
Rowland Phototypesetting Ltd, Bury St Edmunds, Suffolk
Printed and bound in Great Britain by
William Collins Sons & Co. Ltd, Glasgow

To Tom, as always . . .

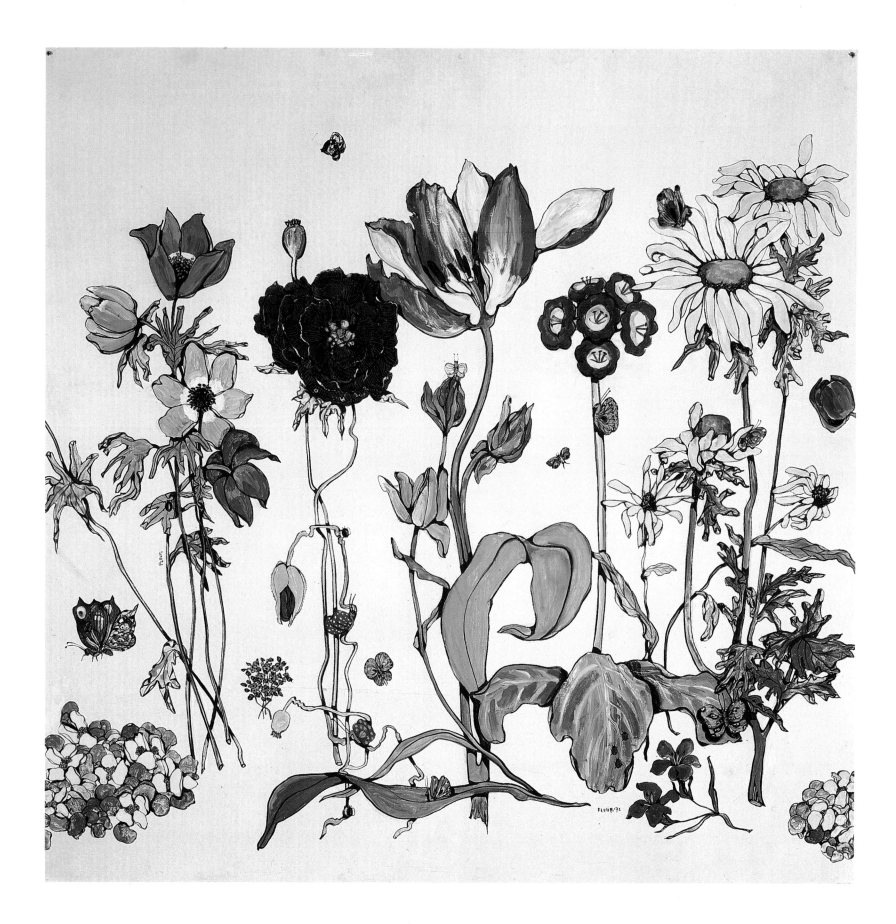

FOREWORD

I fell in love with art and with painters when I was very young. Throughout my life I have sought out their work and their friendship, a path of pleasure which led to my becoming a painter myself. This book is about them and my *own* work as a painter. It has been a wonderful journey.

A vow I made, when I left the US in 1955 to marry an Englishman, led to my decision to leave even certain important paintings behind and never again to hang one unless I already knew or got to know the artist, and certainly never to make a choice based on a 'label'. Except for the few I brought with me, I started a new collection, this time highly eclectic and totally personal. Almost every signature is that of a friend. And every painting is an anecdote.

The result? Three homes are hung with diverse purchases, all by friends – many of them impulsive selections. Some are by raw beginners (a few of whom are now famous), and many others are by such 'greats' as Picasso, Braque, Bombois, Peter Blake, Beauchant, Claudio Bravo, Graham Sutherland and Salvador Dali, whose authorized biography I wrote. All hang together in harmony, having been chosen by a single eye.

The Naïve paintings are the exceptions to the rule. Since some have been bought in faraway places, I haven't always got to know every painter personally. Wherever I go I seek out these innocent storytelling painters whose work I love and collect. Sometimes the fates conspire and friendships are established – even with such strangers as Amazon Indians. All are now part and parcel of my bag of memories, which tie up all that I do collect with the experiences that led to their purchase. I have bought with my heart and not by price or by name.

These artists came into my life in so many ways. As a former editor, I worked on stories about them, chose which to publish, sought out new talent (travelling the world to do so), scoured museums, collected books and books and books to know more about them, their periods and their styles. I soon realized that art and the artist's friendship were inseparable. I wanted to know those whose work I liked and that was a life-enhancing decision.

When I moved to England in 1955, some painters came into my life because I invited them to my weekly Wednesday parties in London. To include unknown painters in interesting groups of people gave me and my guests a chance to know them, discuss their work and, hopefully, give them a gentle push away from obscurity.

One such guest actually influenced my life by the way in which he insisted that I paint! A very young Italian, DOMINIC GNOLI, was introduced to me by his gallery's owner, Arthur Jeffress, who telephoned to ask if I'd help launch the painter's first London exhibition. I went to see his work, bought a beautiful painting, and enthusiastically invited him home on the next Wednesday. All my guests were enchanted by the handsome young Florentine.

He was then in his early twenties, but died tragically of a brain tumour in 1970, aged thirty-six, after becoming internationally celebrated. Dominic started as an illustrator, then became a painter. His talented family was often called the 'Italian Sit-wells'. He appeared on the international art scene when eighteen at an exhibition in Brussels. Eventually, he also became a celebrated author when his first book was acclaimed by *Time* magazine as a classic of our day.

The exhibition brought him to London for the first time. I wanted him to see the English countryside as well, so invited him to spend the weekend with us in our Sussex home. Not long after his arrival, he felt the urge to paint. I took him to a separate sitting room where he wouldn't be disturbed. Seeing him there, amid his paints and canvases, I couldn't contain my own longing to paint.

'Would you lend me the necessary materials?' I asked.

'Yes, I will, but not unless you agree to my two conditions,' he replied before going on to list them: one, that I must not copy him (I was infuriated by the suggestion that I would want to do so). 'You must sit across the room,' he announced. 'And, two, you must not paint anything banal.' By this time I was enraged. I caught my breath, disciplined my response, and agreed to his ludicrous terms, so anxious was I to paint.

What should I paint? I wondered. Suddenly, I remembered the brie cheese we had served at lunch so I went to the larder and fetched its straw mat. Its intricate detail appealed to me (this love of detail I have never lost). I added a few unshelled walnuts, a yellow rose and a golden apple, arranging a still life in the manner of the Dutch – and then sat down to try my luck.

'No, no, no! You simply cannot paint those things! Give me back my paints!' he demanded.

'Young man, if you know so much,' I replied, trying not to snarl, 'tell me what I'm supposed to paint!'

'It is quite simple. You are the person who created the extraordinary *Flair* magazine in the United States. I know the magazine well. My mother treasured and still keeps it in Italy. If you could accomplish that, you must have imagination and memories. *Paint them!*'

I could only gasp but I did push aside the straw, the walnuts, the rose, the apple, and began to paint in the style which I later heard described as Magic Realism. I painted an image which had obviously been firmly and affectionately sealed in my mind, a floating island of pink cyclamens embedded in soil and hanging roots, flying through a deeper pink sky. When Mr Jeffress came the next day to drive Dominic Gnoli back to London, he inspected my finished painting.

'Go on. Go on. You are good enough to warrant an exhibition,' he said as he left.

This took place in his gallery a year later, with the flying cyclamens one of the first to be sold. All the others were sold, too – the nervous début of a new painter was a success.

Dominic Gnoli's inexplicable, undisciplined behaviour, his seeming insolence, and his insistence that I paint nothing 'banal'

pushed me on my way. In over twenty-two years, I've never painted anything that hasn't relied on 'imagination and memory'. Those two remarkably inspirational words actually created my style, kept me from adopting any other technique and gave me my own place in art. Someone once said that work is the rent you pay for life. Painting is a major part of mine.

This book is neither art criticism, nor art history; it mainly weaves together my personal gallery of anecdotes about painters and paintings. Stories are presented without sequence; some are long, some very long, some very short, adding up to one artist's unique journey.

Fleur Cowles

London, 1988

AN ARTIST'S JOURNEY

Camille Bombois

A painter whose work I loved and collected, and whose friendship I shared for many years as a visitor to his home, was Camille Bombois. This Naïve painter is considered by some to be another Rousseau. He was born in poverty and died in similar circumstances, though quite needlessly. My friend, Simonne Gauthier (then manager of our *Look* magazine offices in Paris), and I used to visit him regularly.

The elderly Bombois and his wife lived in a very poor quarter of Paris, in a tiny, sparsely furnished and very ugly little house. Bitterness prevented Bombois from enjoying greater comfort and much wider recognition* before he died, but he was so distrustful of dealers he eventually refused even to give them his work. He became quite isolated, preferring not to sell rather than, as he thought, allow himself to be 'exploited' by any entrepreneurs. In a locked closet in his house were many of the finest fruits of his labour – a treasure-trove of paintings which, if sold, would not only have won

*Bombois was, nevertheless, a favourite of Sir Winston Churchill. Eve Arnold photographed Lady Churchill in January 1973, sitting under a painting of a bulldog – presented to Churchill by Bombois in the most desperate days of World War II.

him acclaim, but provided the luxuries denied to the lonely pair.

He had endured a lifetime of hardship; it began when he served for years as a labourer in a circus (which explains the appearance in his early paintings of clowns). He clung tenaciously to most of his canvases as insurance for his old age.

I was eventually able to buy some of his paintings, paying him what I believed to be the proper market price. Among them were several which I commissioned him to do: I particularly love one of his of a parade of earthenware flowerpots, each planted with a different, very stiff, solitary bloom. The painting represents my ten favourite flowers.

One spring day Simonne and I arrived to find the man close to tears, frightened into a state of near hysteria. What had happened? According to him, the French income tax authorities had just discovered his existence. He had never paid taxes. What could he do? He'd end up in jail, he moaned, wringing his hands. His white-faced wife was even more certain of it.

As this was in the early 50s, before most French income taxes were taken too seriously, we tried to persuade the couple that the French painter's tradition of ignoring taxes was an accepted fact, that he wouldn't end up in jail, that no other painter had, and that I would arrange for *Look* magazine's

French attorney to sort out his problem. This was done. The issue was quickly resolved and forgotten. I never asked what had been done; I was simply told by the attorney to 'forget it'. And I passed this reassuring statement on to the old couple.

About five months later, when next in Paris, I went to see them. This time my companion and I were greeted by warm faces, wreathed in smiles. A round table was quickly moved into the centre of the terrible little parlour with its smell of ersatz linoleum. Upright chairs were drawn up to the table for the four of us to sit round. Something new, obviously a conference, was intended.

After a few moments both M. and Mme Bombois got to the point: How could they possibly thank me for what I'd done? For months, the painter explained, they both worried and fretted about 'How to repay the generous American lady who saved me from jail'. No matter how I insisted he would never have been imprisoned, the fact wouldn't register. They had come to a decision. I simply had to be repaid.

Oh Lord! They're going to offer me a painting, I quickly thought. I couldn't possibly accept it; I mustn't accept it. They had blown the matter out of proportion. I must neither allow myself to take anything, nor permit them to overestimate what had been done.

'Mme Cowles, we have thought it over, my wife and I, and we have at last found the solution,' Bombois firmly announced.

'Please! There is no need for one,' I insisted.

'It doesn't matter. We've made up our minds. You know that painting locked in my closet – the one you have always wanted, the one which I've always refused to sell?'

'Yes, of course,' I admitted.

'Well, we have finally decided. *You can buy it!* The price will be high because we don't really want to sell it!'

It really turned out to be a gift. I was later offered ten times the price I paid, but, of course, will never part with it.

Georges Braque

For countless years, I nurtured a very special friendship with Georges Braque, the result of many trips made to visit him in France, at his Paris atelier, or at the beautiful old farm where he often painted in the north of France at Varengeville.

There were always new paintings to see and art to discuss, delightful face-to-face encounters with this most handsome man. Braque was tall, erect, dignified, almost distant in manner. His deep, deep blue eyes were penetrating and he directed them straight at me when we talked. He liked to paint several canvases at the same time, hence countless easels stood at attention, waiting for his rich umbers, browns, whites and blacks.

His household was an intriguing one, presided over by the owl-like Mme Braque who relentlessly protected him, as did their faithful housekeeper who had served them for dozens of years. Her own daughter, Marietta, was her shadow. Through the years Maid–Marietta made a constant photographic documentation of all Braque's visiting

friends from the art world with the crude, little, inexpensive camera the painter had given her when she was just thirteen.

In winter, Braque and I would sit inside his huge inglenook fireplace having tea and eating the home-made bread he'd plunge on the end of a long, strong twig to toast. Newly-made butter was offered and with it home-made jam. We ate and we talked of painters and paintings, and ended by looking at his current work.

The last time I saw him, just before he died, it was obvious there was something on his mind. We sat on our usual stone seats in the fireplace, but he was strangely silent and preoccupied. Suddenly, he looked up and impulsively asked, 'Would you like to see my secret vice?'

My mouth opened in shock. 'No, no,' I replied. 'Don't show me something you'll regret later. I'd rather keep your friendship!'

He ignored my plea. 'Come with me,' he insisted, eyes suddenly twinkling. So, ruefully (*very* ruefully) I followed his firm footsteps down a path just below the hill, to a large barn. Soon we were standing before its huge doors. What was behind those doors? Would it be unpleasant? Was he harbouring an idiot child, like those in legends? Or some horrible animal – maybe a snake? Or a second studio where (like America's Andrew Wyeth) he secretly painted and repainted the same woman, sometimes nude? It was too late; he flung the doors open and I nearly fainted. There, inside, was a gleaming, beautiful racing car.

'A fast car is my only vice,' Braque explained. 'At night I sometimes take it out and drive like a maniac along the hard sand on the beach near Dieppe. I feel young; it makes me happy. I wanted you to see it; I knew you'd understand because your own husband used to be a racing driver.'*

The fact is that as soon as money allowed him to indulge in his passion he bought his first fast car, but he never drove it publicly or let it be part of his image. It had never been displayed except to close friends who were continually photographed by Marietta in groups around the car.

'Go ahead and snap!' he used to tell her, and she took hundreds of pictures, accumulating a vast collection of portraits of the famous painters of the day, the men and women who gathered at Braque's side. Braque wanted me to collaborate with her, to edit and publish what he called 'a photographic history of the great painters of my time'. After many discussions Braque actually painted the cover design of the book to which he gave the title 'Braque and His Friends, by Marietta, edited by Fleur Cowles'. The painting – a beautiful Braque – now hangs in our London bedroom. I would still like to produce the book once the difficulties which arose when Braque died can be overcome.

Braque's birds have always been a symbol in his paintings. I think I have one of his loveliest, his carved blue and white painted sculpture, which is the design for his ceiling in the Louvre. It was a copy of the original white paper bird in flight which he'd cut out and hung on the wall at Varengeville. Inspired by the seagulls at Dieppe, his birds appear in many of his paintings, in so many periods and styles.

In the early 1900s, he and Pablo Picasso suddenly cut loose from painting in an Impressionist-Realist style when they invented Cubism. They then went on to Abstraction. Braque, like Picasso, remained a central figure in the unfolding of the modern art

*Picasso also loved fast-driving. He had a Hispano and it is rumoured he won several Grand Prix.

movements that followed, yet the last time I saw him, he was again painting the boats on the sand on the beach near his farm. They were far from abstract, and in a beautiful pale palette. I was pleased.

He promised he would make the trip to England for a weekend with us in Sussex. This was a promise I feared would never be kept despite his desire to link up with my racing-driver husband. I was right. He died before it could take place.

Mme Chiang Kai-Shek

Trying to get home to the USA from the Korean War front, I found an unexpected artist. We hopped on a Navy plane for the first leg of the return journey; it put four of us down at its own destination, Taipei, in Taiwan. Mme Chiang Kai-Shek (whom I, and many others who knew her, called 'the greatest man in Asia') was living there. We had met during her State visit to Washington (to which she not only brought a queenly retinue, but also the famous silk sheets she insisted the White House had to put on her bed). I looked forward to an interesting stop-over, and the chance to see her again, and so I called on her even before going to the American Ambassador.

She was painting a scroll (a new hobby in her now dull and boring life). She gave it to me, and with it a beautiful little marble seal, with Fleur translated into Chinese, to be used on my stationery. The scroll, about eight feet long by two feet, was a traditional, fast-brush, ink drawing of a tree with blossoms. Sadly, it got lost when I moved to England. Her frustrated manner and obvious contempt for her surroundings didn't quite marry up with her delicate style of Chinese painting.

In fact, she was quite openly irritated – even angry – to be found living in such mediocre circumstances: in a small, badly furnished home of the size and type usually found in modest neighbourhoods bordering on big cities. She tried to hide her embarrassment by insisting we be her guests – an invitation frankly given as a command.

'We haven't any extra bedrooms here, but I will put you up in our guest house outside the city,' she explained. We piled into her limousine and drove halfway out the driveway before she beckoned the car back to say something that still gives me a chill of horror every time I think of it. I wound down the window and she made clear *what* she'd forgotten to say. 'Don't worry about the rats, Fleur, my housekeeper keeps a boa constrictor!'

Just thinking of a snake (or writing about one) makes me shudder. To imagine this snake slithering around (perhaps sleeping under the low pads which were our beds) still makes me feel faint. The Korean war front, trenches and all, had been infinitely less terrifying, but it was too late now to stay at the American Embassy without insulting Mme Chiang and her husband, then Head of State.

The guest house itself only compounded my fears. I had to stay there until we could beg another lift on an Army or Navy plane headed for California, which happened four days and nights later. Originally built by the Japanese as a rest home for kamikaze pilots, it clung to the side of a mountain overlooking Taipei. The façade was a lacy concrete

design. I never slept, watching for the snake. The Ambassador couldn't rescue us. The gift of Mme Chiang Kai-Shek's painting was hardly a *quid pro quo* for such terrible nights.

The worst was yet to come, however. Before departing we sat and talked in her small sitting room. Not only in a bad mood, but infuriated by the Americans, the former First Lady of China blurted out (looking me straight in the eye): 'You Americans are fools. You have the atom bomb. Why don't you throw it on China?'

Van Gogh

The drama of Van Gogh's painting has always been obvious. As a result, Amsterdam has always been a favourite port of call of mine; there it is possible to see an enormous feast of his work in the Van Gogh Museum.

But I've never been as touched as I was when I came face to face with the undeniable evidence of the period of his insanity. This I saw on a hurried trip to the US in May 1987. The experience followed a luncheon given for me by Ambassador Luers soon after he became Director of the Metropolitan Museum of Art.

A Van Gogh exhibition was due to open in a few days and was already hung in readiness. I was delighted by the director's invitation to see these masterpieces in empty rooms. No crowds. No voices. Undisturbed. I was soon obsessively engrossed by the story told in room after room. The collection was unique; it represented the entire production of Van Gogh's self-imposed stay at the asylum at Auvers, which he entered voluntarily in 1890. He had institutionalized himself 'to get calm', because, as he wrote to his brother, he was 'faced with an illness that breaks me up and frightens me'. When he first entered the asylum, vividness had disappeared from his paintings. Instead, hanging there, were all black thoughts, all his activities, everything he saw in his madness whether indoors or from out his windows: the neat, cell-like room, the asylum's interiors, the grounds, the ploughed fields outside. When nearly recovered, he was allowed to go out-of-doors where he again painted his haunting view of nature's profusion: the brilliance of the sun; the blueness of the sky; the wild contrasts of colour which he loved.

In the asylum he had started by relentlessly painting cypress trees (to Van Gogh, a cypress was as beautiful as an Egyptian obelisk), expressing through them the blackness of his mind. As the exhibition was hung in chronological order it was possible to discern his sanity returning. Eventually, the cypresses were less twisted, their lines less tortured (even straightened); the thickest black lines were now slimmer and the skies were less disturbed.

His madness was epileptic in origin. When he was living through this strange interlude of anguish, his emotional crises were obvious. Walking through each room in the gallery was like looking into a twisted mind returning to sanity. He began to paint gaily just before and just after leaving the asylum – until his death a few months later. Slowly, I walked through the history of his convalescence, which ended in a virtual explosion of happiness and beauty. Gone were the ominous

colours and landscapes and blackness. Joyfully, I found a climax of freedom, a brilliant palette.

One famous painting I'll never erase from my mind's eye was of two women and boats composed on the bank of the Oise river at Auvers – like an overblown postcard, dazzling in colour. But, most of all, I'll always carry with me the memory of those last flowers – not just the ubiquitous 'millionaire's sunflowers' done in and out of the asylum and so recently sold at auction, but the massive bouquets of roses, and mixed flowers in abundance.

When he left the asylum, he wrote to his brother: 'The whole terrible attack has disappeared like a thunderstorm. I could at last paint.' But, no. Two months later he killed himself instead. His coffin was covered in flowers in the colours he loved and had once painted.

Months later, I talked to a London doctor about my experience in the museum, and listened to his theory with fascination. In his view, 'Van Gogh must have been poisoned by overdoses of digitalis (which also was prescribed then for glaucoma and syphilis).' He went on to explain: 'The digitalis could have led to his mental depression, his self-mutilation (he did cut off one ear), his tendency to see unnatural amounts of the colour yellow – the hallucinations of his world of darkness.'*

Today's sale prices of his paintings must amaze you. How much are even the greatest masterpieces worth? Is any painting worth the twenty-four million pounds that Van Gogh's 'Sunflowers' fetched in early 1987? Or the twelve million pounds paid

three months later for his *unfinished* bridge scene 'Le Pont de Trinquetaille' and about fifty million dollars for his 'Irises'? No critic I have spoken to thought any of these qualified as a masterpiece. Shortly after the auction Souren Melikian, in the *International Herald Tribune* newspaper, described the purchase of the 'Sunflowers' at such a staggering price as 'money looking for anchoring points'. This is ironic (perhaps even obscene) when one recalls that Van Gogh sold only *one* painting in his whole lifetime (to the sister of a friend) and died a suicide *in poverty*.

Picasso

I only got to know Piccaso when we planned a *Look* photographic essay about him as a family man. *Was he that?* Yes. In the photographs Picasso is at play with his naked, infant son, Claude, on the beach on the Riviera, hugging, kissing and making faces (which the tiny boy instantly mimicked). There is very little other photographic evidence which depicts Picasso in such a domestic situation. He was already sixty-seven, and the beautiful young mother of the child, Françoise Gilot, hovers nearby. Robert Capa's photograph of her and her son on the sand, with Picasso standing behind holding a huge umbrella to shield them from the sun, is renowned.

Françoise Gilot now lives in San Diego, California as the wife of Dr Jonas Salk (father of the polio vaccine) and is not only Claude's, but Paloma Picasso's mother. Paloma is widely known for her

*Degas had serious eye trouble as well; he was completely blind in his right eye while still in his early thirties and was short-sighted in the other. Cataracts affected Monet's vision, which may account for the yellowishness of his late paintings. Cézanne's diabetes probably affected his sight.

striking beauty and for the creative talent she inherited from both parents. Picasso's children, though living in Paris, spent their holidays with their father. When they came, he gave most of his day to these two manic children, often making toys for them from whatever was at hand. Paloma loved to paint and frequently copied Picasso's inventiveness by using anything available to make the puppets, portraits and flowers her father loved.

That Picasso was ever capable of such abject love that he mourned the departure of a young mistress was recently revealed in John Richardson's biography of the painter. In what must be called a writer's 'scoop', Richardson reveals the neglected evidence of Picasso's secret affair with Gaby Despinasse. It was different from any of his other affairs of the heart.

Billy McCarthy, the adopted son of the art critic and collector, Douglas Cooper, became Cooper's heir when he died. In his collection Billy found the evidence in a cache of drawings, watercolours and letters never before seen or quoted until they were published in John Richardson's book. Picasso, who normally erased women from his heart when he was through with them, had the same pain inflicted on himself when the young woman he adored ended their liaison of 1914–15. He called her 'my love, my angel', and seems to have grovelled before her. He even entwined her name with his in calligraphic lovemaking, sometimes signing his name as Gaby–Picasso (similarly the besotted Salvador Dali also signed many paintings Gala–Dali).

Picasso painted Gaby's portrait, the bedroom they shared, their living room, their kitchen, made geometric patterns for her – eventually painting a love-letter imploring her to return to him. This she ignored.

A Wedding Gift that Became a Museum

In September 1952 I edited another article about Picasso in *Look* magazine, the story of a wedding gift that became a museum.

Jean and Haquette Ramie's marriage evoked an incredible response from Picasso. Jean is the stepson of Mme Suzanne Ramie, in whose workshop in Vallauris Picasso's ceramic plates and objects were produced. No ordinary gift was given to the couple. Soon after they settled into their very modest flat over a vegetable shop, Picasso appeared with a pail, paint and brushes. He didn't quit the flat until he had left paintings on five walls, as well as covering an entire wall with an extraordinary mural.

The paintings were typical Picassos: one, a gay nude, another a plump chicken, another a fish – all painted as if they were actually framed paintings hung above the dining table (each with its own painted nail and wires). He painted ceramic plates where real ones should have been placed on the mantelpiece. A cement patch in the floor was covered with painted tiles. Fake ivy trailed up from the fireplace.

The *pièce de résistance* was different from any Picasso we know; it was an eleven foot mural in the tiny sitting room (which took him a mere half hour to paint!). In it, Haquette peers out of a high window in a medieval castle. A Florentine page boy below is blowing his horn to welcome Haquette's bridegroom, arriving on horseback. His attendants follow behind. All were painted in an unexpected,

realistic style and had no relevance to the abstractions of the others.*

Impulsively, he next made a final gift of a 'genuine' Picasso: a framed paper collage which he'd copied from his own 'La Dame des Poissons', then placed it on yet another wall – the only one not painted *on* the walls.

This anecdote reveals a romantic side to Picasso. But was he generous? Did his gift literally imprison the couple inside the exceedingly modest world in which they'd chosen to begin their married life? The paintings, if moveable, would today be worth many millions of pounds but, except for the collage, nothing can be moved or sold.

I bought my own first Picasso ceramic in 1950 – a blue and white abstraction of an expressive face on a large square plate. He had begun to do ceramics after watching other experts, finally deciding that ceramics were another 'canvas'. Enormous production followed.

When I feel strong I wear an incredibly heavy piece of gold jewellery designed and signed by him, a gold link bracelet from which a thick gold circle hangs, engraved with a classic Picasso satyr. I didn't expect anything delicate from the man whose work was so alive, so dramatic and so outspoken it infuriated many millions, fascinated even more, and made him one of the highest priced painters of his century. Someone once described him as a comet which puts the stars to rout.

*I'm reminded of the very realistically detailed circus tent curtain Picasso made for the ballet, *Parade*, performed in Paris in 1917.

Peter Blake

When my friends tell me they can't paint because they can't draw, I say 'Try collage – it only requires cutting and pasting together things you like to make in any kind of composition. It could be of flowers, streets, landscapes with trees, or objects. No matter – try it!' I always insist.

Collage was, in fact, the instrument of Braque and Picasso and many of the Cubists when they broke away from the earlier Post-Impressionists. But it is England's Peter Blake, the forerunner and master of today's Pop Art movement, who, I think, has taken collage to its finest form. The Cubists made their collages by using odds and ends of materials and mixed media, often pasting together printed pages culled from magazines and newspapers. Peter Blake, a superb draughtsman, further experimented in scale, in texture, in subject, and ended up making a historical record of today's culture in collage as well as in paintings. His work parallels the world (part of it real, part of it his private one). To show us as we are, he cuts out photographs, labels, magazine covers, lettering and postcards (often mixing them with paint to work out his ideas).

His retrospective exhibition in 1986 at London's Tate Gallery was a remarkable scrapbook in which we see ourselves as he sees us. He has no fear of change, in fact he is the only painter I know who has been willing to include unfinished work in a museum exhibition (as we saw at the Tate).* The

*There are always works 'in progress' – some to be seen ten or more years from now.

famous 'Loelia the World's Most Tattooed Lady' and another, a still life, were both lent by me.

I discovered Peter Blake when he was a student at the Royal College of Art in the mid-50s. I have always taken great pride in that discovery. I still go to the College regularly, always interested in new talent and eager to help a student find success. To this end, I have recently inaugurated a Fleur Cowles' Award for Excellence at the College: £7500 will be given to the best graduate each year. I have established this award to provide inspiration for young artists, and help them bridge the gap in their careers between art school and their future as independent creators.

A Catalogue Raisonné

One of the nicest tributes ever made to me was by the man who secretly kept a catalogue raisonné of every one of my paintings. I only discovered its existence years after he began. It must be unique (and, of course, it is a touching gesture).

Whenever I finished a painting, including even the very small ones I once did, a photograph was quietly taken and filed away. In large ledgers he stored these facts: the name of the painting; its size; if exhibited, *where* and *when*; its price; if sold, to *whom* sold; if in a book, *which* book (already five books by Robert Vavra have appeared, written around paintings I've done);* if bought by a museum, *which* museum.

This unsolicited but unbelievably devoted effort has been the idea of the ex-Royal Marine, John Cross, who was our chauffeur for thirty-two years. Only by chance, while driving with him, did I discover his secret. I wondered out loud who had bought my first five foot by four foot painting. 'Oh, I can tell you that,' he replied. 'I have been keeping a record of all you've done ever since you started!'

I've since seen his huge stack of ledgers – often compiled in Mr Cross' spare time while sitting at his wheel, waiting. I was stunned when they were revealed, quite overcome by his thoughtfulness. I now have that rarest of all things possessed by any artist – an itemized record of the life of over one thousand paintings, a complete history of my work.

Tiger Flower is the best known, published by Collins.

Hitler

The Viennese Exhibition at the Pompidou Museum in Paris in the spring of 1987 was one I could not miss, if only because of the many Klimt paintings in it. To single these out is not to denigrate the rest of a fascinatingly thorough history of Viennese art from 1900 to the beginning of the war. But to any Klimt-lover this exhibition was a celebration, including more of this painter's work than had ever been previously seen, many never having been shown before.

His life-size portraits of women and his famous (or is it infamous) male and female lovers are stunning.* The minutely detailed mosaics of paint he used were often accentuated in gold to magical effect.

The Klimts were only a small part of a huge show of paintings, drawings, books, furniture, sculpture – enough of everything to exhaust any viewer. Suddenly, I felt I'd had enough; the exit door was ahead and I made for it. But I wasn't free. My husband, still inside, insisted I come back to see four architectural paintings hung just inside the doorway. They were of streets in Vienna, realistic and perfectly drawn. The signature? Adolf Hitler!

Rumour had it that they were purposely put near the exit so that weary observers would pass them by. When the exhibition did move to the Metropolitan Museum of Art in New York, those four Hitlers were withdrawn. I still cannot believe them to have been the work of the infamous 'house painter'.

*One of his many, many portraits of Eugenia (Mado) Primavesi, done in 1913, sold in New York in 1987 for $3,850,000; another of his paintings went for $3,300,000.

Naïve Paintings

Even as a youngster, I was especially delighted by Naïve paintings, totally bewitched by portraits of stiffly-posed little boys and girls (with their ubiquitous cat or dog alongside) which were the products of itinerant painters in America's colonial days. They travelled from place to place with their paints, brushes and almost-finished portraits, which required only a portrait of the sitter and his actual clothes to be added. Children stare at the viewer impassively; formality is equal to whimsy. Today, these enchanting paintings (many in museums) say a lot about American and Mexican settlers' lives.

As I grew older I got to know more about Naïve painters (their work is also called Primitive or Folk art).* Ninety-five out of every hundred of today's Naïves are untaught. Such matters as perspective, realistic colouring and normal subject matter are of no importance to them, storytelling *is*. What others write with pen and ink or type, they narrate in paint, ignoring technical skills. Some are dream-like, some haunting, all innocently portrayed and most beautiful and desirable, an antidote to our mechanized world. I live with many.

To me, Naïve painting is an organic element in the history of art. Eclectic collectors enjoy them, but many others ignore them. Many are still in the anteroom, waiting to be discovered, but if I could look at an anthropologist's study written in 2088,

*It can be maintained, pedantically in my opinion, that Naïve art differs from Primitive or Folk Art in that it is not produced by unsophisticated societies, but by untrained artists in a sophisticated society. However, I use the terms interchangeably.

I'm sure it would not overlook the documentation made by Naïve painters.

Some Naïve painters have been house painters, furniture finishers, miners, ploughmen and needle-women who traded their needles for brushes. Many cannot distinguish between reality and image – and therein lies their charm. Some say even PAUL GAUGUIN started exploration of this sort when he turned to primitive people in the South Sea Islands to find the reunion with nature he needed.

But it was the DOUANIER ROUSSEAU (who died in 1910, laughed at and scorned until Picasso and other great painters bought his work), who gave us the first major motifs, so popular with later Naïves, by painting the sort of images other artists had not known how to invent. How well he succeeded was proven when the last Rousseau painting offered on the open market many, many years ago was sold for one million dollars. It was a bargain then, and today would be worth vastly more.

Others like him, such as my friends, Camille Bombois and André Beauchant, have followed, so have dozens of others. Such paintings are just as admirable to me as those that are abstract or figurative which, like all paintings, have their own language. But the Naïves speak by reducing life around them to a state of innocence, a sometimes haunting, sometimes mystical state.

Naïve art seems to thrive well in countries so vast or isolated that folk imagination is left to its own devices. Away from museums and from other painters, this art flourishes without interference, without critics or even the thrust of other people's ideas and notions. Haiti is a prime example. It is one of the poorest islands in the Western world, where for too many years an unhappy population rejected realism by painting flights of fancy and dreamlike escapism from their brutally suppressed lives under the former dictators, Papa Doc and his son, Baby Doc, Duvalier.* Today, their natural gaiety is again apparent, but some still remember the dictators and paint memories of those dreadful days. Voodooism is as popular today as ever (just as *condomblé* is in Brazil).

My first purchase of a Haitian Naïve was in 1951. I paid a mere $250 for it (considered then a large sum even by the painter). Times have changed. Recently a 94-year-old man, OBIN, sold a painting for $10,000. HIPPOLITE, the high priest of the VOODOO SCHOOL, sold one for $100,000.

Hippolite not only painted but began to look for other local painters, a year later he opened the Art Centre in Port-au-Prince. Most of the painters made their living by sending work abroad to known collectors, of which I was one. My favourite acquisition is of a spider on its web which is somehow unfrightening (despite my terror of the real ones), painted by RIGAUD BENOIT.

HORACE PIPPEN is the Negro who painted the life and scenes of his people in the southern United States. Wounded in World War I, and invalided for life, he turned to painting and left a rich documentation behind.

CAMILLE BLAIR, widow of STREETER BLAIR (who is described on page 60), painted for me a most amusing barnyard scene which is also highly decorative. Her ducks walk on water (can't they swim?). She has no sense of perspective, but the result is wonderfully happy.

*Millionaire Baby Doc fled to France in 1986. Flaunting an extravagant life style, although accused of embezzling millions, he is said to own a valuable collection of countless Haitian primitive paintings, rumoured to be stacked away in a Washington, DC, warehouse.

The Duke d'Urcel of Belgium, who knew my interest in Naïves, told my husband and me one evening at dinner that he'd heard about a woman Naïve painter 'somewhere in the north, near the sea'. He couldn't be more specific but as we had time to spare before putting our car on a Channel steamer, we left early the next morning to find her. This we finally did by knocking indiscriminately on doors here and there along the northern seaside to ask if anyone knew of a lady painter. We did find her, were enchanted by her work, and bought several. Not long after, MME GRARD had a terrible accident which left her totally paralysed. I arranged for an exhibition of her work to be able to send money she needed and deserved.

I've described some of the painters whose work I own to show the range of my collection. But another Naïve painter, ANDRÉ BEAUCHANT, a former nurseryman, was a French Naïve whose work I was probably the first to publicize (in *Flair* magazine). He took up painting during World War I when, by chance, an officer admired his telemetric drawings and advised him to draw. He began by composing in his head the pictures he eventually painted, merging landscapes with people, and people with mythological and historic scenes about which he'd read. At last he decided he was an artist and began to paint those imagined pictures. Thirty years later, his large show in Paris caused critics to compare him with Rousseau. His 'portrait' of a 'family' of pansies, posing amid tall trees, hangs in my drawing room.

He once explained to me how he starts his pictures: not at the top, but at the bottom. 'This is like my plants which bury their roots deep in the soil. I make my paints in secret colours. I have no studio. I paint in my attic, which is very big, unless I am doing something so big I must go out-of-doors. Then I build a shelter over it . . . if one feels like painting, it comes out. Otherwise, it is better to cross one's arms and wait.'

JEAN EVE, before he began to paint his meticulous versions of the factories and streets on the banks of the River Seine, began first as a French mechanic, then a steelworker, railroad employee, customs agent and, finally, a painter. Recently, I actually drove down a street across the Seine from a scene I'd bought!

I bought my first paintings of the YUGOSLAV SCHOOL in a London gallery; they were later shown at the Edinburgh Festival. Most of what I know about the artistic community in which Yugoslav painters work comes from my friend, Anatole Jakofsky of Paris. His book, *Peintres, Naïf*, is the acknowledged encyclopedia of folk art around the world. He has written extensively about the Yugoslav School. Once he pointed out, 'Yugoslavia was a country as patriarchal and medieval as it is possible to imagine. On the eve of the last war, just before it was swept into socialism and the machine, there were only a few painters . . . Now they are accepted as painters who busily record lives, deaths, costumes, the painted images that may have lingered in their minds since childhood.'

Among them IVAN RABUZIN's paintings are my favourites. He was a joiner by trade before he began to paint and quickly became a poet of space. I especially respond to one I have of his village where giant pink roses hover above house-tops in a touchingly beautiful pastel palette. He is a Pointillist, painting in thousands of dots.

Another of my own Naïves is by the cowboy from Blanket, Texas, called H.D. KELLY. He became a painter when already old, after a fascinating career

first as a muleskinner, then a bull whacker, a teamster, a steeplejack, a railroadman, a machinist and a cowboy – to name but a few of the trades he practised in thirty states in America. He described himself, after turning to canvas, as 'a horseman who likes to paint'. He drew on his memories of fifty years, finishing one painting a month for an important queue of collectors, of which I was, fortunately, a successful one.

Before varnishing his pictures, he always removed his 'trademark', those specks of Bull Durham tobacco he never failed to spill on every painting because he rolled his own cigarettes. My painting is called 'Penning Goats', a vertiginous look at a Texan farmyard crossed by a parade of goats.

Once, when in Brazil, I heard about a 'mad' painter living on an island outside the harbour of Rio. A local collector-friend took me by boat to see his work: it turned out to be one of the great finds of my life! RAIMONDE DE OLIVIERA, born in 1930 in Bahia, committed suicide some months after I went there. He was a pauper, leaving behind a forlorn message in the lid of a shoebox, claiming his dealer had taken as much as 80 per cent of his sales.

He was untrained, could hardly read or write, but dedicated himself to painting his own imagined tales of the Bible. The one I chose on that island visit is of 'Angels Building the Ark'. It is extraordinarily beautiful. Since his death I have tried to buy others, but have discovered that all the paintings he left in his studio were taken by a Swiss dealer, who refuses to sell them. Is he waiting to create a higher-priced market, I wonder?

My friend, MADY DE LA GIRAUDIÈRE, lives in Lavelanet in the foothills of the Pyrénées in southern France. En route to Spain we often stop to partake of her superb cassoulets. She paints the same landscape or village square in her world near Toulouse, often four times over, to show them as they are in each season of the year. After her first trip to the United States, which she saw by Greyhound bus, she painted her memories. The painting of hers which I keep in Sussex includes, in one large canvas, the Quaker barns, farms of the Mid-West, covered wagons and other symbols of the simple side of America. She is certainly France's greatest primitive painter and the exhibition I arranged for her in London was a sell-out, as are those she has in many cities of Europe.

I also have four paintings by an English painter, HERBERT LLOYD, whose work was introduced to me by the art critic and historian, Herbert Read. His strokeable farm animals and farmlands are almost photographic, but, miracle of miracles, they are painted in watercolour in what seems like millions of tiny dots.

I suggested to Sir Paul and Lady Wright, when he was Ambassador to the Congo, that I would be interested in the work of any Naïve painters they could uncover. They didn't fail me. Now hanging over the mantel in my dining room in Spain is an underwater scene of fish and flowers by PILI PILI. The fish move; the flowers wave like a mirage. Pili Pili is too good for obscurity.

Paul Dufau

I cross the path of unknown painters in odd ways, looking for them in curious places. Most unexpected of all was the French farmer, Paul Dufau, whose life I was able to alter completely.

At the end of summer in 1963, when my husband and I drove home to London from Morocco, we stayed one night with friends, this time in a forgotten little valley near Agen in southern France with a fascinatingly eccentric, wealthy Parisian who had deserted her husband. Though we were almost unexpected, a dinner was instantly arranged for us after we arrived, with forty astonished local farmers invited to dine in her vast candlelit barn. I was seated next to a sheep breeder, who seemed the poorest of the lot. He was blue-eyed and serious, a 69-year-old man called Paul Dufau, whose gnarled hands spoke vividly of his hard life. We spent the dinner discussing his sheep (I with great difficulty), but when he rose to go he turned to me and said, movingly and modestly, 'I also paint.'

I thought of little else that night. I had to see his work. We crept silently out of the house at seven in the morning to find Paul Dufau. Everyone we asked sent us on our twisted route to the farm of the man they called mad – 'who paints'.

I expected the Naïve paintings of a lonely person who put pieces of his life on canvas. Not at all. His paintings were full of stature; I could honestly have been in the studio of a famous painter – a young Klee, a Dubuffet, or a Miró. Braque, I soon discovered, was Dufau's idol.

His studio was a disused dilapidated barn. Deep piles of paintings covered the floor, sometimes three feet deep. Although he had started to paint when he was only eight, he had never sold a painting until I came along. He could never afford canvas or board, using instead either cheap discarded mounting board picked up from the local photographer or torn portions of empty cartons discarded by shopkeepers. He couldn't afford paint so he eked out what he could buy by using the soot taken from the fireplace for the black paint he needed, and for beige, ecru and light brown, he dug up the sand outside the barn, mixed it with a tiny dose of real paint to cement it to his painting to produce a beautiful tanagra-like surface. The large Christ I bought from him, created entirely of these sands and black, is a moving and important creation. The first time Xavier de Salas, Director of the Prado Museum in Madrid, saw it he exclaimed: 'It could be a Goya!'

I arranged an exhibition for him in the Grosvenor Gallery in London a year later – a sell-out of over ninety paintings. The farmer was no longer impoverished; soon there was a bulb to light every corner, a tap inside the kitchen sink that replaced the well, a refrigerator and, most joyful of all, a tractor! Ultimately, he earned enough (with my help, other sales followed) to buy a car, and then brought a twinkle to his wife's eye by presenting her with a television set!

I brought him and his wife to London for the *vernissage* of his first exhibition. They had never before been on a plane. He never dreamt anyone else would buy his paintings, even though I had already bought nineteen. For the opening of his London exhibition, he dressed as always in brown corduroys and boots, making only one concession to the event by tying a thin, black cord around his collar. At my dinner for him, attended by the

French Ambassador and his wife, he was in tears.

Seven years ago, tragedy befell the family when he suddenly went blind. Not long after, he began to use clay and sent me a beautifully sculpted sheep which his gifted, knowledgeable hands helped him to shape – a gesture of his affection for me, which I found most moving. He recently died.

I shall never forget him. His paintings are everywhere in our three houses and, in my office, are all his framed letters. Each one is illustrated by a painting of either the rose he knew I loved, or a heart, or an animal. Each one was meant to say thank you, but it was he who enriched my life.

An Unforgettable Painting

I do try to persuade my friends to go to Colmar, near Strasbourg in France, to see an unforgettable painting in the Musée d'Unterlinden. No one can view this masterpiece without being struck by the impact of this, one of the world's greatest religious paintings, the five-panelled story of Christ, called the 'Isenheim Altar', by MATHIS GRÜNEWALD.

American Ambassador and Mrs Edward Streator, my husband and I left Paris in the spring of 1987 to motor along the Rhine through France and Germany. The city of Strasbourg was our epicentre and we arrived there laden down with instructions. Valuable ones came from a member of my staff whose home was Strasbourg. The rest were countless pages of 'must do's' and 'don't do's'

from England's distinguished columnist and author, Bernard Levin. The Rhine is his territory, in fact one of his passions. He had just followed the river's full course to make a British television series, which also became his highly readable book *To the End of the Rhine*.

Under no circumstances were we to miss the altarpiece, both men said. It took Grünewald seventeen years to paint. Above all (despite its richness and skill) I was quite overcome by the overwhelming evidence of the *pain* of the Crucifixion: the *pain* on St Antony's face, the *pain* on all the other faces, the *pain* on Christ's face – His fingers twisted in agony as He was tortured to death. The altar is not like other religious paintings, but 'a wall of terror', as Bernard Levin put it.

Henry Moore

No one needs to look for a name to recognize a Henry Moore statue. I knew him so well that he once generously lent a statuesque female sculpture for years to the World Wildlife Fund's Switzerland headquarters as a personal favour to me.

I'll never get over the irony that I could have owned many of his wartime underground drawings. When you are constantly surrounded, as I was as an editor, by quantities of newly-revealed art, editorial judgements are made and works of art automatically returned to galleries. Some could have and should have been bought.

I have a pang when I think that I had dozens of

Henry Moore's 'underground' drawings, many Magritte paintings (one on a bottle), and masses of other now-famous works of art in my hands, and they slipped through my fingers.

Coco Chanel

After Coco Chanel died, her beautiful apartment above her couture house was preserved as a shrine. It rises above the grand staircase leading from her atelier; anyone who ever attended a press opening must still see her there (as I do), suited, hatted and imperturbably silent as she watched her 'classic' collections (and the audience's faces) as they passed before the fashion journalists. Variations on her style regularly appear in other great fashion houses everywhere, often direct quotations of her dateless ideas.

Recently, when in the Chanel salon in Paris, Karl Lagerfeld (who is now the fashion supremo of Chanel couture) suggested my husband and I might like to go up to see her apartment again. I had lunched twice with Mme Chanel before she died, always in almost total silence as I listened to her non-stop talk, as fascinated by her eclectic home as by her conversation.

As my husband and I walked up the familiar beautifully-curved stairs to the drawing room, I saw it exactly as it once was, totally unchanged. My restless eye immediately spotted one thing I was looking for – a tiny painting of a lion, still in its

beautiful antique gold frame – one of *my* paintings! When decisions were made determining which possessions were to be left untouched, the little lion had been left in its place. Chanel was a Leo.

Voyage to Rome

The four Marx brothers couldn't have written a better script than the voyage to Rome of thirty-five of my paintings. Destination: the Obelisco Gallery, one of my earliest exhibitions.

My paintings are always framed before I send them to an exhibition, but apparently this wasn't the way to do it in Rome if they are imported for sale there. The preview of the exhibition was on a Tuesday. Completely by chance, on the Friday morning before, the owners of the gallery passed through London on their way from the United States to Rome and called on me to be sure the paintings had gone. They had not. I planned to ship them that same afternoon by air freight and to follow them to Rome by air a few days later.

'No. No. No. You cannot ship framed paintings without an import licence!' they exclaimed. (I've never been able to find out why I hadn't been told this before or how they expected to frame them 'overnight' in Rome if I had sent them unframed.)

'Today is Friday. Government offices are closed on Saturday and Monday is a national holiday! Tuesday is the opening. Hundreds have accepted invitations. *What can we do?*' they wailed. They

were no more distressed than I, but I replied, 'Don't worry. I think I have friends who can help me.'

I called Mme Pandit, then India's Ambassador to Italy. 'May I ship them to your Embassy? They won't be stopped by Customs if I do?'

'Certainly,' she answered. 'But this won't be a help to you as they'll have to come in on bond and that will then take days to clear.' So I called the American Ambassador. The same reply.

Suddenly, I thought of a friend, a very well-placed gentleman in Rome. 'Don't worry,' he replied. 'I'll ask the Foreign Office for a clearance and I'll meet you at the airport with the proper papers and an official.'

I had already decided not to send them by air. He and everyone else was notified I would be coming by train on Sunday, accompanying the crated paintings to avoid other problems. I could keep a figurative eye on them all the way . . .

To keep me company (and more importantly, to calm my nerves and charm any fussy Customs men at the Italian border) I invited a very beautiful Italian friend, now Lady Dashwood, to come too (my husband flew over two days later). She and I watched as the crates were loaded on to the train in London. We stood on the platform in the harbour as the crates were again loaded into the ferry to cross the Channel, to make sure they got aboard with us. We then saw them lifted from one train in Paris and on to the Italian train. Every step of the way we watched over them – from train to ship, then from ship to train, in Paris too – to see them safely on the last stage of their journey. Finally, we relaxed our vigil.

Our next worry was at the border. When the Customs men did knock on our door in the early hours of the night, the beautiful Marcella talked to them in Italian. A few entrancing gestures and her glorious smiles did the trick; the train went on its way. We roared with delight.

When we got to Rome, we thought a celebrity must be on the same train, there were so many people and photographers on the platform. They were waiting for me! American and Indian Embassy personnel (each had brought a van to transport the paintings), my Italian friend, Foreign Office officials and my beaming husband were all standing by. After greetings and embarrassed thanks for the great trouble they'd all gone to on my behalf, someone asked about the paintings. Where were they? 'Oh, just behind us, in the next car, the baggage car,' we answered, walking a few steps to reach it.

The car had disappeared! Someone had uncoupled the carriage en route while we slept. We both agreed later that we had heard a few jolts, but had thought nothing of it. Hysteria followed, not only from us but from all the other passengers who had had baggage in the same lost car. No one could tell us where it had been re-routed. A terse 'We'll investigate' was all that could be elicited from either the stationmaster or any other official.

It was Sunday. The *vernissage* was scheduled for Tuesday. Where were the paintings? I cannot remember spending a more harassed two days. 'We are still investigating,' the railroad officials reiterated.

Tuesday morning, at noon, the crates were delivered with the help of the Foreign Office. How, or from where, we never found out, and by then we didn't care. It took us a frenzied five hours to hang the thirty-five paintings and divide them properly between two floors in the gallery. At six o'clock, the guests poured in. No one had the slightest notion

about the hilarious circumstances surrounding what was to be another successful exhibition.

Two Peruvian Paintings

This is a tale of my two Peruvian paintings. My ninth-century castle is in a somewhat Martian, though extremely beautiful, part of Spain called the Extremadura. In the sixteenth century this land was so harsh, so unyielding, so dominated by rock crags (as high as twelve feet above the ground), with food so hard to grow and the population so poor that men gladly followed Pizarro across the Atlantic in tiny vessels in search of gold, as conquistadors hoping to turn their poverty into riches in the mysterious new land of Peru.

I have described this episode in history merely as a backdrop, because I have two remarkable paintings of it. The one that matters most is a portrait of a very regal, aquiline face of a man, splendidly handsome, only seven by ten inches in size, surrounded by a monumental gold and mirrored frame which makes the picture end up four foot square – sloping twenty-one inches from the portrait to the back of the frame. Its companion, a conversation piece depicting a family in their garden, is equally dramatic.

For fifteen years I wanted these paintings but they were unavailable. Eight years ago, through the affectionate machinations of an ambassador friend to the Argentine living in Peru, they were actually bought and shipped to me. My strange obsession had caused the portraits to be brought back to the 'home town' of the conquistadors. The portrait turned out to be of the Inca (Prince) Garcia de las Vegas, son of one of them. He eventually came to see my town, loved it and lived and died in it after writing a definitive history of the conquistadors.

Portinari

Portinari was a famous Brazilian painter, whose work I was originally introduced to in New York's Museum of Modern Art; later, in the Brazilian Embassy in London, I got to know two of his beautiful paintings belonging to Ambassador Sergio Correa da Costa and his wife, Zazi. In the end I became a friend of Portinari's widow and family in Rio de Janeiro, and saw them for dinner on one of my once-yearly trips to Brazil. His widow had the stoic look of a woman who'd lived a hard life. His lovely daughter-in-law (with whom I still correspond) is a gifted writer.

One night, after dinner, I was treated to the totally unexpected luxury of a retrospective show of Portinari's work. One by one I was shown examples of his work, from his earliest drawings to the last paintings he did before he died. Slowly, the tiny salon became a crowded museum, stacked with work ranging from realistic flowers to non-objective ones, as well as religious paintings similar to those I've seen in a beautiful Brazilian chapel in Belo Horizonte.

It was the first and only time I have had a

private retrospective exhibition held for me. Unforgettable.

Graham Sutherland

Late in 1970, I wrote to Graham Sutherland at his house in the South of France to ask him if he'd let me include in a book I was writing,* what he knew about what had happened to the missing portrait of Winston Churchill which he'd painted – a much-discussed and much debated story. When Bernard Baruch and I had visited Churchill at Chartwell, the three of us had talked about the portrait at length, and enthusiastically.†

The portrait had mysteriously disappeared, lost somewhere in limbo after having been seen only by Churchill's family (and very briefly by a few of his associates at its presentation by the Joint Parliamentary Committee [Chairman, Sir Charles Doughty] who had commissioned Graham Sutherland to do it). Despite the great outcry, Graham Sutherland remained silent. Would he change his mind and talk to me about the experience?

To my delight, the elegant man gallantly appeared at my door in London very soon after, ready to talk. Because of the importance of the conversation, I decided to use a tape recorder. Needless to say, I was touched by Graham Sutherland's confidence.

*Friends and Memories, Jonathan Cape.
†See p. 62.

His visit helped dispel the rumour I'd believed about how 'Churchill used to doctor up the portrait every night'. That proved to be a canard. Graham Sutherland never, in fact, left the portrait behind: it was painted at his house in Kent from studies made at Chartwell. He didn't normally let a sitter see a portrait before it was finished, not even the studies, because he took them home with him each evening.

It was fascinating to hear Mr Sutherland explain how Churchill had wanted his portrait painted. He demanded at the outset, 'Are you going to paint me as a bulldog or a cherub?'

'This depends on what you show me!' replied the painter.

Churchill insisted on sitting on a dais to be painted, something entirely new for the painter. 'I saw a great deal under the chin and under the nose!' Sutherland admitted before he went on tape. We continued as follows:

GS: We have been talking about the family.
FC: And about the difficulty of sitters who 'prepare' their faces for action.
GS: And about Mary Soames and Soames.
FC: Mary Soames and Soames – were they very helpful and cooperative?
GS: Yes. The eventual difficulty may have come from Lady Churchill.
FC: Is it known that she put her foot through a Sickert?*
GS: That's what he told me.
FC: He said so himself, yes? Was this to intimidate you; that you'd better make it right, or else she'd do the same?
GS: I don't think so. We were talking about

*See p. 34.

the number of portraits that he had had done of himself.

FC: How many had there been?

GS: Oh, lots. 'I couldn't count them,' he said. I said, 'Well, which did you like best?' He said, 'Well, I rather liked the Sickert that was done of me.' And I said, 'Well, you worked very well with Sickert.' And, in fact, he did, perhaps better under Sickert than under anyone. As far as art is concerned he was very impressionable. If some quite bad painter said he should work in a certain way, in that way he worked. He was very malleable in that way; it was a strange sort of modesty – even to the extent, towards the end, of taking advice to work from photographs projected on to the canvas.

FC: Chameleon-like? . . .

GS: No, not just changeable, but from ignorance and modesty.

FC: He didn't feel superior?

GS: He'd take advice from any painter who happened to be there. But not in anything else but painting. There was no question of that. And he said, as to the Sickert portrait, 'Well, Clemmie didn't like it at all . . . she put her foot through it.'

FC: What I am really interested in (now that you've been able to disprove the crazy notion I had that he did 'doctor up' your portrait, and how sad I am to lose that anecdote) is, how ever did the story get around?

GS: I don't know. It is conceivable that I *had* accidentally left something there during my daily visits to Chartwell, but I know I was very careful to take things away every day. Careful because, as I told you, he'd asked me to show him every day's work and I was determined not to. He said, early on in the sittings, when I had explained that I showed neither the day-to-day studies nor the final work until finished, 'Come on, be a sport, after all I am a fellow painter.' It puts me off terribly for people to see my intermediate stages – even how my thoughts are developing (which are always tentative at that stage . . . that's the whole point of making studies). So I had to compromise. I would show him something innocuous every day. I tried to make a substitution by putting the real study I was doing underneath it. I succeeded in doing this most of the time.

FC: You seem to have got away with it?

GS: All but once . . . I made, one day, a drawing, and he looked at it and said, 'Oh, oh, this is marvellous. Why, this is going to be the *finest* portrait I have ever had made.' The next day he happened to see the real one – which I was working on. 'Oh no, oh no, no, this won't do. I haven't got a neck like this. You must take a quarter of an inch – nay, half an inch – off my neckline. I want to be painted like a nobleman.'

FC: This is so revealing. I consider this to be a kind of mental touching-up of a portrait. In effect, he *did* touch up your work, by making an attempt to direct it.

GS: Of course.

FC: This, in fact, was what he was

attempting to do, even if he never got his brush to the canvas.

GS: I think he might have liked to touch *anything* up, because being another painter it would be almost irresistible not to feel that he could do it better himself.

FC: Now tell me about the man that you met during those ten sittings of an hour each: did close scrutiny reveal a man you liked better or less after that?

GS: Better.

FC: Better?

GS: He was always considerate, always kind, always amusing and cooperative. When he wasn't cooperative, he didn't know he wasn't being cooperative. I think this is fair to say.

FC: And he actually meant to be?

GS: He *meant* to be cooperative, and in fact often was. We talked about everything, not only painting, but politics and so on. I think we got on well. He liked to paint out-of-doors with people, you know. He would say, 'Oh, I do wish that you'd come out with me and we could do the same subject.' But it didn't turn out like that with me, owing to the circumstances surrounding his dislike of the final painting.

FC: How could he be against it? Did he actually watch it continuously – despite it not being your practice to allow it to be seen?

GS: He was only against the portrait when he first saw it. But I think he was suspicious of what it might become . . .

FC: Did he actually press his way to see it at a stage when you would normally not allow it to be seen?

GS: No, he didn't even do that. By the time he saw it, the actual portrait was finished.

FC: And then what?

GS: I have explained that the actual portrait was not ever at Chartwell. It was done at my house in Kent. He said that he was not shown the portrait before the presentation. I can only say that it was delivered to Downing Street twelve days before the presentation.

FC: Is that fact known?

GS: Whether it's known or not I don't know; he did write to me after the trouble to say it was not so much that he didn't like the portrait, but that I didn't show it to him before the presentation. This to me, to this very day, is the great mystery because, in fact, it was delivered by my own carrier, as I said, to Downing Street, between ten and twelve days before the presentation.

FC: Well, the mystery remains: *what happened to it?* (a) Did he really see it and wish to claim he didn't? or (b) Do you think it was deliberately kept from him?

GS: It might have been kept from him. I just don't know.

FC: What happened at the presentation?

GS: What happened at the presentation might interest you – on the day that Lady Churchill came down to my house to see it (Randolph had previously seen it), Willie Maugham was also a guest, and Willie was very kind and helpful. He said,

'Graham, it would be very embarrassing for you to see it in front of Lady Churchill. I will go up with her to your studio and if she likes it, I will whistle down for you. If she doesn't like it, you'll hear no whistle.' And so Willie whistled down, and I came up and she was in tears, saying, 'I can't thank you enough,' and 'It's absolutely marvellous,' etc., etc., and I was pleased, naturally. And when we came downstairs, she said, 'Now if Winston wants to know what it's like, have you got a photograph?' I said, 'Yes, I have – but I would personally advise you not to show him a photograph because the portrait will be delivered in the next three days; my carrier will be coming; and there is no reason why he shouldn't see the actual thing rather than a photograph.' However, she decided against that. She wanted the photograph. So I gave her the photograph.

FC: In black and white or colour?

GS: In black and white, which is never accurate (and it wasn't a very good photograph anyway). At nine o'clock that evening a big black car drove up to the house. A large, very important looking letter was handed in by the chauffeur. It was a letter from Churchill which said, 'Dear Mr Sutherland . . . ' (I'm paraphrasing slightly now) 'While I would always be happy to have my features delineated by you, I do not think what you have done is a fit subject for a presentation portrait. The ceremony, however, can go on because my friends in Parliament have all signed a very beautiful presentation book.

Yours sincerely, Winston Churchill.'

FC: Good God, how awful! Would you object to my quoting the letter exactly?

GS: I may not be able to put my hands on it.

FC: But was this the accurate essence of it?

GS: It is a paraphrase. You probably should see the actual letter; you would find it almost identical. If I could find it, I would let you see it. There's no reason at all why you shouldn't, and I would like to be dead accurate. A copy may have been kept. This was a handwritten letter.

FC: I hope you still have it. It's a letter you should have kept.

GS: Well, I'm sure I've put it away. I keep my things sometimes *too* carefully, and then I can't find them, but this was the gist of the letter . . .

FC: How hurtful to you . . .

GS: Oh no! But I immediately got on to the Chairman of the Committee (the portrait hadn't then been presented to Sir Winston) and I told him what had happened. He said, 'Oh, this is very serious. I must go straight away down to Chartwell.' He telephoned me at about a quarter to eleven that evening and he said, 'Sutherland, forget entirely about that letter. Everything's all right.' I said, 'What have you done? This is marvellous,' and he said, 'Well, I don't know, I'm not a lawyer for nothing.'

So the ceremony did go on. After, we went to a party in the evening at Downing Street and Churchill was very nice. He

said, 'Well, Sutherland, we may not agree about matters of art, but we shall remain friends.' That was that.

FC: Was the presentation of the portrait made at the ceremony?

GS: Yes, it had already been made in the morning. Willie Maugham was extraordinarily understanding and was shocked about what he thought was bad treatment. He said, 'You know they are really awful . . . this is too much . . . they behaved very badly to you . . . you mustn't mind,' and so on. I didn't mind, oddly enough. I said, 'Well, what about Lady Churchill crying with pleasure in my house?' He replied, 'Well, now she says she was crying from disappointment!'

FC: How extraordinary . . .

GS: It's not without amusement, I suppose!

FC: I think it's a fascinating story about how a great man behaves when personal vanity is concerned – or how a situation can be created around a great man.

GS: You must never think he really behaved badly to me, but the situation was funny. I didn't take real exception – even to the letter. Randolph, I think, was silly and more than silly. He made matters much worse when I met him on Onassis' yacht; he said, 'Oh, I'm rather sorry to meet you because I feel the family have treated you so badly . . .' 'Not at all,' I replied. 'Why? Everyone has a perfect right to dislike a thing if they want to.' It's written into my contract always. He repeated, 'Oh, well, I think – we think – we behaved badly.

But *why* don't you write to my father and say how sorry you are that you didn't please him?'

FC: What an idea!

GS: So I thought. But, still, I had nothing to lose in doing so, and it might have pleased – so I thought – an old, rather bemused man.

I did write to the old boy: I said, 'I'm sorry I wasn't able to please you, but if I had the portrait to paint over again I wouldn't do differently. Nonetheless, I'm sorry that you were not pleased by it. I would have liked you to be pleased.' A letter came back saying, 'It was not because I didn't like the portrait but because you didn't show it to me before the presentation.' That was the last straw. I thought then, well, one can't go on forever arguing with a mind already made up.

FC: It seems an act of petulance – because you had sent it to him.

GS: Can you imagine my not showing it to him before a presentation? It would be the very last thing I would do. But then, I was dealing with such a mercurial character, a little suspicious, as I am myself. On the whole, I got on with him well. I liked his company. I sometimes lunched alone with him. Quite alone.

FC: The studies which Beaverbrook bought from you for the Churchill section of his museum, were they, in principle, more or less the same?

GS: Oh, no; they were enormously varied – some in Garter robes, because he wanted

at first to be painted thus; then he changed his mind. He thought he'd rather be painted as a parliamentarian. And then I had made one of him smoking a cigar; another one, in duplicate, of him reading a letter. I suppose there must be, including drawings, about eighty items altogether in the museum.

FC: How incredible – eighty sketches in connection with one portrait.

GS: Not far short – not all done at Chartwell, and sometimes from memory when I got home.

FC: Are they now mainly in Canada?

GS: They're all in Canada in the Lord Beaverbrook Museum . . . Max Beaverbrook sent an envoy down to search my studio to see that I had sold the whole lot.*

FC: A very crafty man!

GS: A little naughty perhaps – even crafty, but I was fond of him. And a bargain was a bargain; I had agreed to sell him everything.

FC: And so the scraps of paper were all picked up?

GS: Yes, except for one or two that the envoy didn't find.

FC: That pleases me for one reason: if the painting has been destroyed and is gone permanently, perhaps there's a sketch somewhere which is similar to it?

GS: There is one study – it is more close to your work sketch, more, perhaps, a compositional 'layout'.

FC: And where do *you* think the portrait has gone?

GS: As to the whereabouts of the portrait, I think that the Committee has been very weak with Lady Churchill. After all, they had the right . . . he was to be the owner during his lifetime only.

FC: Should not Parliament have been able to say where *is* it – to enquire after its conservation?

GS: They say they will not do anything until Lady Churchill is dead; but, that's all very well. Foreign countries want to borrow it. It was specially asked for by the Germans for my retrospective exhibition last year. And I wrote to Mary Soames to ask if she could do anything. She said, 'Well, I'll ask my mother, but I can tell you straightaway that I know she will never yield.' So that was that. But it was a nice letter, not unpleasant at all. She has much of the old man's occasional sweetness. Part of his greatness was that he was often very funny. Do you remember about the special food for the goldfish? You know all about that? Bought at Fortnums!

FC: Yes. He told Mr Baruch and me about it, once.

GS: About the Communists?

FC: No.

GS: Well, you know, he would take a great big handful out of the tin and fling it into the pond, but the throw wasn't big enough for the ones at the back to get it. So I mentioned that this seemed a little unfair. 'Oh, well, you know, that's life,'

*A remarkable portrait, which is a copy of the one destroyed, hangs in the house of a friend in Chelsea.

he replied. 'I mean to say, the Communists expect everyone to have everything equal. But life is not like that. The ones at the back don't necessarily get a share!'

A Brazilian Indian

To me, art need not belong to any special school. This I've proven by collecting Photo-realism, Naïves, Impressionism and Abstraction. I tend to haunt museums and suffer from impulsive fits of passion for certain paintings. But I've chosen mainly to collect only those by painters I've got to know – these have brought either beauty, gaiety, lyricism, innocence or magic into our environment.

A modest painting completely expresses this; I commissioned it from an untaught Brazilian Indian. Giving him paints I challenged him to try his hand. This, his first painting, is an imagined, beautiful Indian bride, riding on a white horse on her way to her wedding – in a world of flowers and birds. A tiny silver Christ hangs over the horse's mane. Pointillism is a word the artist never heard before nor knew about. To him, there was no other way to paint, except by applying thousands of tiny dots. The painting now lives in Spain, and brings the room instant beauty and serenity.

Saul Steinberg

How did sardines help secure a remarkable series of drawings for *Flair* magazine? My staff and I thought up an idea which required the creative skills of the American humorist-painter, Saul Steinberg, to execute. Sardines helped.

We hired an empty warehouse and painted one of its brick walls in white. We then rented props to photograph against the wall, backgrounds on which his satirical drawings could be added, such things as bedsteads, a Victorian bureau, an over-embellished three-panelled glass screen, burlap bags of rubbish, and even one empty, white brick area. Each one, we hoped, would be turned into a Steinberg composition if he drew his ink sketches directly on the photographs so they ended up as Steinberg originals.

Although he enthusiastically agreed to do so, Steinberg kept putting me off. Telephone calls merely produced promises; promises were constantly broken. He was so much in demand, he couldn't find the time. One day, tired of his procrastinations, I called my car, stopped at a delicatessen, bought fresh bread, butter, lemon and a tin of sardines, and rang his doorbell.

'Hello, Saul. I'm here with lunch (the sort I think you'll like) for you and me to eat, after which you're going to do the drawings you've promised to do for so long!' We ate it. We enjoyed it. We talked merrily – and Mr Steinberg produced a set of drawings-on-photographs which are collector's items today.

His hawk-nosed women are portrayed in whatever situation the photograph suggested: a woman asleep is added to one in bed, in another one, she is

sitting upright. Vases on top of Victorian drawers become other women. One is standing on her head against an empty wall. Each panel of a screen became the body of a lady, arrayed with full plumes in her hair. They are hilarious, and they were seen by the 365,000 readers of *Flair*, all thanks to a tin of sardines.

Salvador Dali

Salvador Dali never opened his mail. Mme Forain, who was authorized by him to go through his desk, often opened letters which were at least four years old. When I wrote my book about him,* I insisted he initial every page of the manuscript so he never could nor would make a Dalinian fuss (or sue) over a word of it. I mailed it to him in April, saying that the deadline was six months later, on 1 October after which the book would go to press. I waited anxiously, realizing he might never open the package, but on the morning of 1 October, a messenger brought the manuscript with every page signed without one change, except for an added fact which improved one story I had written. The next day he sent me a telegram: 'You have written a *monument historique*.'

*See p. 45.

Dürer

I worship the skill of Dürer, that remarkable Renaissance man (who must also have been most handsome and refined to judge by his self-portraits). As I do, he loved everything in nature (if any proof is needed think of his famous rabbit and sheep). Because I love detail, I yearn to paint grasses, plants and leaves as he did in one particular painting called 'Das Große Rasenstück'. I also love his painting of a dove's wing. I like the variety of his work, his ever-changing subjects. Violets will never be more beautifully portrayed than in the tiny bouquet he painted. His iris (the flower which so many painters, whether Eastern or Western, have felt they must paint) is flawless. It must stand comparison even with a Muhammad Riza, an Ehret or a Redouté (even a Van Gogh), all of whom have painted irises, as have the Japanese and the Impressionists. However, I am most touched by Dürer's.

Galleries

I think galleries have obligations to a new painter. If the painter's work is worth exhibiting, that is reason enough to see the artist through what might be a traumatic experience at the start of his career.

Once an exhibition of my own followed a young Czechoslovakian painter's. When I spoke to him, I concluded from his story and his appearance that

he'd probably mortgaged his life to pay for the expensive cost of shipping his work and himself so far outside his Iron Curtain homeland. He didn't sell one painting . . . I think the gallery ought to have bought one. I was so full of compassion, I bought one I didn't even like (destined for the basement) to help him save face, and I never went back to that gallery again, despite my own success there.

'Three Thousand Years of Nigerian Art'

A few years ago I was able to bring a majestic collection of African art to the Royal Academy in London called 'Three Thousand Years of Nigerian Art'. After it ended its American tour at the Metropolitan Museum of Art in New York, the exhibition was packed to return to Nigeria. Ekpo Eyo (who collected and produced the extraordinary exhibition as Director of the National Museum of Nigeria) and I are friends; both of us have served on the same Foundation Board in the United States. On his way home to Nigeria, he stopped in London to explain that London was 'out' as far as exhibiting the collection. 'Why?' I asked.

'Because the British Museum wasn't even willing to lend me a few of its prize Nigerian pieces.'

'The Royal Academy, not the British Museum, is the best place for this exhibition,' I announced with concern.

'All right, if this is so, I leave it to you to deal with,' he said, then he flew off to Nigeria.

The fates conspired in a magical way. At the very time I was talking to Ekpo Eyo, the Exhibitions' Secretary at London's Royal Academy, Norman Rosenthal, was in New York attempting (without success) to bring the exhibition to London. Learning that I, and I alone, could arrange for it was exciting news for him.

Financing the exhibition was the next hurdle, but in the end the cost was generously met by Mobil Oil. The £5,000,000 value had to be insured and the exhibition cases shipped and mounted. To help meet the high costs (by staging the exhibition in a number of places), the directors of the Hermitage in Leningrad, the Pushkin Museum in Moscow, and the National Galleries of Denmark, Sweden and France were invited to foregather at the Royal Academy for a day at the invitation of Sir Hugh Casson. An exhibition schedule was worked out that allowed each enthusiastic gallery to host the exhibition and yet return all to Nigeria six months later, and thus fulfil Ekpo Eyo's conditions.

I was happy to be the begetter.

Portraits

As I've discovered over many years of experience, commissioning portraits can be a danger as well as a delight, and always a gamble. If one is vain, which I hope I'm not, a portrait becomes the most revealing evidence of the passage of time. Fortunately,

after being painted by seven artists I heartily dislike only one: a full-length over-romanticized version. It lingers in our basement waiting to be robbed of its beautiful frame in favour of one of my own paintings.

In 1947 the masterful photographer, Blumenfeld of New York, did two very different portraits of my head, using a camera instead of paint, and using his unique manipulative technique to give these photographs the look of fine drawings. They now hang close to my three-panelled screen, painted the very same month of the same year by the Hungarian Marcel Vértes.* I am the full-length figure in the astonishing beauty of a woodland scene. Screen and photograph marry well, indicating how I looked in 1947.

The three portraits of me I am proud of were painted by René Bouché, René Gruau (like a modern Toulouse-Lautrec, with whom he has actually been compared) and Claudio Bravo, the aristocratic Chilean painter. Bravo came into my life twenty years ago when I discovered him after seeing a Botticelli-like portrait of friends in Madrid: today he is an immensely sought-after painter. My portrait is a masterpiece of draughtsmanship, which he took a year to finish (though he had only taken an hour to sketch my head and hands before going back to Madrid to work).

He painted a circlet of cyclamen flowers around my neck (a reference, he said, to my name and my love of flowers). The background is the dry Spanish desert we both adore, broken by occasional mountains which punctuate much of Claudio Bravo's work. He drew the background mountain range straight across my chest to depict 'strength of character'.

Although he is now one of the world's most celebrated artists, he has turned his back solidly against doing any more portraits. 'I'm over that foolish period,' he recently stated. What he has done since is equally masterful.

Sometimes I wonder if Zurbarán, the Spanish painter of ancient monks in white robes, inspired Bravo, who also paints white textures as few painters can. Zurbarán's white robes are real enough to touch. When in Spain I occasionally manage to get to Guadalupe or Cadiz to see these masterpieces.

But, no, if any artist did influence Bravo's work, he denies it. He once said that he only goes to museums 'to see what other artists have done so as not to do that myself'. Another time, describing how he works, he said he 'prefers to paint very large pictures. Painting such large canvases gives me the feeling of swimming or floating through space. It's like painting a symphony.'

He applies a pale undertone to his canvas, sometimes making only a most schematic, preliminary drawing on paper. Today, once he has a definite idea in mind, he paints it directly, as he considers colour more important than drawing. He is a realist, but insists his pictures transcend reality.

A tribute to the exquisite, elegantly literal style of his work occurred unexpectedly the day the extraordinary modern painter Francis Bacon, came for a drink. Pausing by Bravo's portrait of me, to take in its technical skill, he drew in his breath and asked, 'If I could draw like that would I paint the way I do?'

Bravo also brings Stubbs to mind; like him, Bravo has the same obsession with accuracy.

*Marcel Vértes was a fashionable favourite in America, famous for the beauty, gaiety and wit of his work. Like Prince Rainier of Monaco, he loved circuses, especially the horses, which he constantly painted. To him, a trapeze artist was a swallow.

Stubbs haunted London zoos for cadavers of cheetahs and tigers, then skinned them to study their anatomy. For the sake of accuracy, Bravo had the head of a lamb cut off in order to paint it.

Whenever the word portrait comes to mind, I have to think of Helena Rubinstein; she was the indomitable good friend who accustomed my eye to so many new things, walking about with her in Paris or New York. This woman, who emigrated from Poland to Australia (where she started what was to become her enormous cosmetic empire), began to collect like a magpie even before she became rich, and she seldom made a mistake. Some of her paintings or sculptures were bought impulsively, some possibly as investments. In the end, she built up one of the world's most interesting collections, especially of African art but including dozens of modern masters. Though originally a humble Polish emigrée she really had a miraculous eye.

She adored portraits of herself, and commissioned fifteen painters she thought could deal with her powerful face and personality. They were a diverse group: Christian Bérard, René Bouché, Raoul Dufy, Count Emmanuel Castelbarco, M. Closset, Paul Cesane, Helleu, G. Maitland Kessler, Marie Laurencin, Edward Bernard Lintott, Louis Casimir, Ladislav Marcoussis, Roberto Montenegro and Baron Kurt Ferdinand von Pantz. Two others (in my view the best) have often been reproduced. One is by Salvador Dali, the other by Graham Sutherland, both of whom were completely successful in capturing her character.

Picasso agreed to paint her portrait but she never saw it finished before her death. 'What's your hurry?' Picasso would ask every time she urged him to begin. 'You and I both have many years yet.' She died aged ninety-two, too soon for Picasso to act.

The Degas-Gauguin Notebooks

I have a beautiful notebook. In the late 1870s, Edgar Degas, with a playful flourish, filled a sketch book with some scenes made at the home of his friend, Ludovic Halévy, where he and other friends were visiting. The talk must have been lively to judge from the sketches Degas made of their time together.

Years later, a very limited edition of his unique record was reproduced and I bought one. No one who sees it believes it isn't Degas' own original, so extraordinarily well have both paper and drawings been reproduced. One can almost hear the group's convivial conversation about the habits and occupations of their world in the late nineteenth century. In fact, one can imagine the heady aroma of gaslight, of cigar smoke and cognac.

One of the photographs in my notebook shows him gaily demonstrating to his friends that not only his painted ballerinas could dance. Bearded and aged, he is making a little whirl of his own. The men who spent the weekend at M. Halévy's home met regularly, but the soirées ended after five years. Degas' sight was failing. He became a recluse.

A few years ago I had an experience which parallels this anecdote about Degas' notebook. Armand Hammer (the billionaire oil man, public benefactor, long-time friend of top Russians and

one of the world's greatest collectors) telephoned me from Claridge's where he was staying on one of his trips to London. 'Will you come and have a drink with us?' he asked.

'Yes, I'd love to – provided there aren't too many others,' I answered. I abhor large cocktail parties.

'No, we'll be alone,' he promised.

When I got to Claridge's I started up the stairs leading to the Royal Suite, where he always stayed, but the concierge called me back. 'Mr Hammer is not upstairs, he is in *there*,' he said, pointing to the huge room where cocktail and dinner parties are normally held. I was furious, but looked inside. The room was crowded. I closed the door silently and crept away. A few seconds later, I felt an arm on my shoulder. 'Please don't go,' Mr Hammer pleaded.

'No, I'm sorry. I cannot bear crowds.'

'All right, don't go in. Sit down in this armchair outside and see what I am celebrating,' he said, as he handed me the notebook he'd bought that morning for £400,000! 'I couldn't help calling my friends. Study it. Enjoy it. I'll come back in ten minutes to take it back.'

I sat down, the tiny notepad in my hands, as he disappeared inside the door. I held one of the most exciting objects imaginable: it was Gauguin's notebook! On both sides of each page there were drawings, colour sketches and miniature paintings of life at his Tahitian hide-away. A jewel more precious than any gem.

The Hoaxer's Trade

A large exhibition of Naïve painters at the Musée National d'Art Moderne in Paris, which I flew over to see some years ago, revealed a trick of the hoaxer's trade. It was so large, covering more than one floor, that I stayed on for nearly three hours. The 'greats' of contemporary Naïve art were all there – most of them must have been valued at vast sums.

There were very few of us in the museum but I was always conscious of a midget-sized man who moved very, very carefully from picture to picture, and from floor to floor. So often did we look at the same painting that I finally noticed he had the smallest notebook I'd ever seen in the palm of his tiny hand and he was busy sketching. At last, too curious to ignore this, I stood close enough to see what he could possibly put on to such small pages. He didn't mind being watched. He was copying signatures!

I suddenly remembered my friend, Kenneth Clark's, remark that 'the real expert could tell if a painting was the original or a fake by carefully studying the signature, a hard thing to fake'. The little man's obvious job in life was to supply signatures on demand.

You can buy genuine fakes today. In Cremona in Italy, at the Art Faker's Collection, 300 forgers openly sell copies of other people's paintings (some are, unbelievably, commissioned). Every painting is documented and stamped as an authentic fake. The certificate states that one has bought a genuine copy!*

*From *Art and Antiques*, 1986.

Salvador Dali

George Bernard Shaw once told H. G. Wells that every historic personality, in fact any person of importance, could be characterized by three anecdotes. I have dozens about Salvador Dali emanating from the period just after the war when we met in New York until the time, years later, when I wrote his authorized biography, *The Case of Salvador Dali*.*

To have embarked on a book about a living man contained awesome difficulties, particularly as I had no help from time or history in the taming of a fiercely untameable subject. I had no chance to look back on Dali's life; the best I could do was to look straight at his living record. The result was a bestseller; the critics decided it was 'unbiased' and 'an immensely readable' subject. I wrote, in fact, a massive compendium of his stunts, confessions, anecdotes, jokes, bouts of paranoia, literary and other creative skills; re-arranging the ominous mass of legends by which the press, art historians and friends sought to describe him. Dali had always been good copy since he regularly stripped the veil of secrecy himself from his own activities.

In one review of his lurid memoirs, *The Secret Life of Salvador Dali*, which he wrote in the 40s, the *New Yorker* magazine said that 'No man in our time, not even Hitler . . . has exploited his paranoia with greater efficiency.' It took a certain courage to enter such a maze, but I ended up with something like a case history, not an orthodox biography.

I'd known Dali well for ten years before he asked

*Published by Heinemann, London.

me to write the book when we were having one of our many, many 'unscheduled' lunches in New York. He had a curious habit. He would sit on a chair near the revolving door of the St Regis Hotel on East 55th Street (where he lived and painted in a bedroom). At the luncheon hour, he kept an eye on the entrance to the Pavilion Restaurant directly opposite. Whenever I went in, he'd wait ten minutes or more before crossing the road. Suddenly, he would be standing at my table. It became a drill.

'Do have some lunch,' I would always say.

'No, me no hunger,' he'd reply, meanwhile sitting down. The scenario was always the same: as soon as my food arrived, he'd pick up my knife and fork *and eat my lunch*. As I was diet-mad at that stage in my life, I never minded forfeiting it, delighting in yet another example of Dali in full flight.

I wrote my book in three parts: 'The Man', 'The Genius' and 'The Paranoic' (in this section I was greatly aided by receiving clinical facts from his analyst in Paris who described Dali as: 'a person in a normal state of health, without organic disorders, but who lives the whole time in a world apart from and different from the one we call normal').

'Has there ever been a more many-sided man?' I asked myself when I finished. I cannot imagine anyone else who could be described as I did him in the book's introduction:

. . . the megalomaniac, so amusing the friend, so uncontrollable the student, so wicked the child and brother, so wild the dandy, so passionate the Vermeer-lover, so social the gadfly, so polished the draughtsman, so super-realist the Surrealist, so skilful the Cellini, so gifted the author, so nimble the Midas, so impressive the poet, so royalist the thinker, so creative the

scenarist – designer – librettist – couturier – sculptor – jeweller, so extrovert the showman, so playful the humorist, so erudite the scholar, so controversial the painter, so complex the Catholic and so devout the worshipper of his wife? Will there ever be a more colourful member of art's history?

One of my best Dali anecdotes originates in Paris, where he arrived in the 20s. He was like a boy-child released from a monastery. He needed friends and had a great one in Joan Miró, who had praised his work so extravagantly before both of them left Spain. Dali soon stunned the smart set of Paris when Miró took him to lunch with Dali's first socialites at the home of the Vicomtesse de Noailles ('my first Maecenas' he called her). Later, people like Coco Chanel, the Maharajah of Kapurthala, Elsa Schiaparelli, and a scattering of ex-dukes and counts made up the Dali circle of immediate acquaintances. Aristocrats being his passion, he organized his time to invade their ranks, from which there were financial as well as social gains to be extracted.

At the Vicomtesse's luncheon, Dali heeded Miró's sharp lesson about society behaviour and used silence as a tactical weapon. He rarely spoke a word, and reinforced this behaviour with an epic example of his paranoid thinking. Every other guest had been forewarned they'd be meeting the 'mad Spanish Surrealist' at this elaborate meal at a beautifully set table with a footman standing behind each chair. The guests were hardly prepared for what followed.

Dali not only didn't speak; he didn't touch the superb food. He brushed the first course away, refusing even to allow a plate to be set down before him. No one paid too much attention to his odd behaviour until he refused the main course. The hostess, now concerned, asked, 'But, Mr Dali, are you ill?'

'No!' the gaunt, wild-eyed Spaniard replied. 'Oh, no, no, no, no! *J'ai un régime très fort*. I'm occupied at home eating my china cabinet. Ha! Ha!'

Conversation stopped. He thought he'd been funny. No one else did. *'Mais, quel type de cabinet?'* the Vicomtesse finally managed to ask.

'Oh, a very nice one – keep glasses in it – modern, not antique furniture!'

'Good Heavens! How dangerous! You don't really eat glass?'

'The glass is not dangerous. I chew that up very fine. It's the wood that gives the trouble!'

A stunned silence descended. Their conversation had been odd enough, even for such sophisticates, to end all talk. Composing herself again, the hostess picked up where she'd left off: 'How long have you been eating this cabinet?'

'About three weeks, but I finish it in six months.'

'You mean you're just living on glass and wood?'

'Oh, no, I have coffee and a croissant for breakfast.'

Later several glassy-eyed guests accepted his invitation and went to his modest room to examine 'the cabinet'. They found what he had promised: a cabinet with a huge hole somehow gnawed away, and glasses missing too! One of those visitors was a close friend of mine, Alfred Frankfurter, editor of the American art magazine, *Art News*, to whom I owe this story. The incident went round Parisian circles with the speed of a flash fire. He was no longer an *inconnu*, but an overnight celebrity.

Many years later, when writing my book, I read this text to Dali to confirm it, and also to ask him to

describe how (outside of my 'stolen' lunches) he would describe the food he was then eating. He gave a precise reply, without hesitation: 'I like food in very definite forms,' he replied. 'The best is to choose food with the bones outside and the flesh inside – like lobster and crayfish. This way I am the first to taste. Such creatures have a genius-idea to wear bones outside instead of inside. Intelligent, don't you think?'

'As for birds – such lovely forms! They wear their armour and skin together (especially little birds). I, Dali, am absolutely crazy about their craniums. Never touch lettuce. It has no form, no legs, no face. Food has to be something architectural.' (If he ever actually ordered a lobster, he'd ask for 'food in armour'.) He finished by saying, 'I know what I eat; I do not know what I do.'

Another anecdote is an hilarious account of the perils I encountered when I went to visit him at his house in Port Lligat in Spain, a tiny harbour on the northeastern stretch of the Costa Brava, an integral part of the painter's eccentric existence. I had to make the journey there to observe his life style and the paranoic world he created wherever he went. I spent three years researching in Spain and France to check up on all the terrible tales he told me about himself – all beyond belief, but all true! Nobody ridicules Dali better than he does himself.

He used to oscillate like a pendulum between his two lives. Satiated by the loneliness and, at the time, obscurity of his home in Port Lligat, he would have to touch down in New York among the international socialites necessary for the publicity he periodically craved. He needed them as a cloak to wrap around his inner sense of insecurity. He also always stopped en route to New York in Paris staying at the Meurice Hotel to make contact with the jet set there. Ensconced in his suite (it had once been reserved solely for the use of King Alfonso), he would gather around him a colony: whoever was available among the poets and the writers (and certainly the journalists for more of that publicity that fed his ego), as well as the ubiquitous art dealers (some legitimate, some not).

He had two live ocelots on a leash.

When he had had enough of life there, and in New York, his paranoic mind would crave solitude once more and he would find it by going back to the loneliness of Port Lligat.

While in Madrid in 1959 to talk to Dali's former fellow-students from the university, I suddenly and unexpectedly found Dali in the foyer of my hotel, and was greeted by him so lavishly that the splendidly elegant Ritz shuddered. He insisted that now was the perfect time to visit him at Port Lligat.

'How do I get there?' I asked. 'Geography has never been a strong point of mine.' (Incidentally, though he pretended to most people he was only able to speak in Catalan, for years we always conversed in 'broken' English, but that sufficed.)

'Very simple. Fly Barcelona, catch train to Figueras. Putch telegram before. My secretary meet,' he ordered. Translated, he meant that his secretary would meet me if I telegraphed details of my journey, which I did with the tireless help of the hotel concierge in working out flights and train times (including the change of the train to Cadaqués instead of Figueras, which was supposed to be nearer to Port Lligat. This was my first error).

Two days later, I left. Being Dali, he had given me the wrong advice; he should either have sent a car to meet me in Barcelona (a long expensive journey from Port Lligat but he was a millionaire), or suggested that I hire one myself, something I

would have done if I'd remembered that every confrontation with the man had its hazards. Visitors coming by land to see him at his harbour home never pleased Dali, who preferred them to arrive by sea (the bigger the yacht the better), and so he rarely discussed any other form of travel. The train from Barcelona was slow, crowded and hot, but I finally reached Cadaqués. From there to Port Lligat was as surrealist a journey as any Dali painting.

His telegram in reply to mine promised that his secretary would meet me in Cadaqués. When I got there, already weary and regretful, I found no one waiting. I looked everywhere for a mysterious unknown secretary (would this mystery person be male or female?). '*Secretaria* to Señor Dali?' I asked the shopkeepers in the town's tiny square. Shrugs of bewilderment greeted me; I vacillated between taking the next train back to Barcelona and/or ordering a car to drive me to Port Lligat. I decided to do that.

My next hurdle involved finding a driver. The local taxi, run by an octogenarian, seemed as old as he, and he refused to take me. Even if the road really existed, his tired old vehicle couldn't risk the journey, he explained. Finally the lure of extra money, paid in advance, combined with persistence, eventually worked wonders and I stepped into the battered wreck. (There is now a good road to the village of Port Lligat: today it boasts a large hotel and tourists galore, but it was like no man's land when I went.) It soon became obvious that the car couldn't cope with the potholes, crevices, rocks and up-and-down hills. What if the car broke down, I worried? Wouldn't I be morally responsible since the driver had never wanted to go?

All my questions were answered when a particularly high hill loomed before us. The engine struggled to inch us up the incline, then turned over

and died. Meanwhile, we slipped backwards, a few yards at a time – not without lost heartbeats – before coming to a stop.

Suddenly, a Vespa motorcycle appeared over the top of the hill – with a man shouting excitedly! '*Mais vous êtes très vite! Je suis le secrétaire de Monsieur Dali. Bienvenue!*' I was not too early; *he* was two hours late! His beaming, unconcerned welcome, waving my telegram, was irritating.

There were a few loud screams in Catalan (which I couldn't understand) exchanged between the driver and secretary! I assumed (and hoped) the driver had been offered more money and a promise to get someone to help him with his car. I was then invited to join the secretary on *his* vehicle. This was my first (and last) ride on the back seat of a motorbike. I was scarcely prepared: wearing a dress and Dior coat, which had to be pulled high, and clutching a suitcase in one hand and a handbag in the other with no free hand to cling to bike or driver, I prayed as we took off.

We sailed up the hill; only prayer kept me on that seat as we navigated one hill to face a new one. We jostled along slowly for what seemed an eternity, often missing one large rock merely to jolt into another. The driver was fearless; he knew the way and was full of certainty. At last, from the top of a high hill, I saw the exquisite little port of Lligat below me. In those days it was an empty cove, except for a tiny hostel and Dali's home constructed out of several inter-connected fisherman's cottages, which lay at the edge of the incredible harbour that so often appears in Dali's paintings. There the man himself, with Dalinian moustache twittering in delight, stood before us, dressed in odd clothes.

The motorcycle skidded to a halt. I couldn't save myself, so fell off. I landed on jagged stones; every-

thing I owned scattered before me. Helped to my feet, I realized that one leg was bleeding profusely and I was covered with bruises everywhere else. Dali was hysterical with delight. Looking at the blood and the pile of rubbish which represented the contents of my suitcase, he cried out in glee: 'Wonderful! Wonderful! Very Dalinian arrival!'

Another Dalinian anecdote concerns his 'legitimate' copy of Vermeer's 'The Lace-Maker', which he simply signed Vermeer by Dali. He was actually commissioned to do it by Robert Lehman, the New York banker who had previously created the world's largest private collection of medieval paintings. Dali had been invited to see the collection in Mr Lehman's home; they wandered through it together, Dali in silence. When they reached the door, Dali turned back and made his only comment: 'No Vermeer'.

'No Vermeer painting is available or I would own one. Why don't you paint a Vermeer for me?' Lehman replied.

Although Vermeer had always been Dali's idol, he declined. Years later, Mr Lehman repeated the offer: this time Dali did accept, on his conditions. Mr Lehman agreed to all of them – first to his price. There were other demands: Mr Lehman must ask the Louvre to provide a canvas made exactly as it would have been for Vermeer in his own lifetime. Secondly, he requested that every book about Vermeer be found for him ('So I can live just like him,' Dali explained).* And lastly, he wanted at least one of the maps Vermeer always kept in his studio, 'So Dali can keep same'.

All was made ready. Dali painted a Vermeer that

*He was painting in a hotel bedroom all the while!

could indeed pass as a Vermeer, although the Metropolitan Museum of Art, which inherited the vast Lehman collection, may not agree.

Painting a Vermeer was only one of Dali's eccentricities. On another occasion, when he was asked to appear on television with me in London at the launch of my Dali biography, he agreed on condition that he could paint while on camera. He was then going through his 'pistol-painting' phase: sometimes he would drip coloured paint out of the muzzle of a gun, but this time he aimed at, and shot paint straight out of a gun on to the canvas before him – the camera duly transmitted it on to the nation's television screens. *That* Dali now also hangs in my collection, in my office.

He and his gun were not copying Jackson Pollock. He painted his first 'Jackson Pollock' many years before by dripping colour on a canvas stretched out on the floor. He also claimed that he painted an 'Andy Warhol' Coca-Cola bottle before Warhol had even grown up.

His most traditional Surrealist paintings were not experimental. He combined his own weird, irrational ideas with meticulous painting, going from the banal to the magical, from religion to science. Meanwhile, he accepted commercial offers to paint on ties, and wrote a remarkable piece of personal psychoanalysis (a book of self-revelation if ever there was one), as well as essays on astronomy. Lastly, he bottled Dali perfume (art into scent?).

I offered him a commission when I was editing *Flair*. Would he write and illustrate one of his favourite subjects, which we had often discussed, 'mimicry in nature'? He agreed, but only if I personally would help him find the butterflies and moths he needed before he could do it. I was amused enough to take time out of my frantically

busy life to wander around New York City streets with him in search of a lepidoptery shop. Fantastically dressed and carrying an outrageous cane, the sight of him tended to stop pedestrian traffic. 'Must have butterflies' and 'Where are the moths?' he kept exclaiming.

We found our shop, which he nearly emptied to supply his avaricious needs. The result was worth the heavy cost, which I not only counted in money but in weary feet and exhausted nerves. The finished article is an exercise in Dalinian creativity, and certain evidence of genuine literary skill, brilliantly written and original.

The subject of insects mimicking nature in colour and texture for safety's sake, both absorbed and frightened him, as if it were a nightmare. 'Of all the wonders of nature, most surrealistic is mimesis in nature,' he wrote, reminding one that the leaf butterfly does imitate a leaf in a manner worthy of the most refined of the *trompe-l'œil* painters.

'Now I feel a period coming for leaf-women, stick-women, autumnal-wood-women,' he explained later. For the owl-women (which he painted for his article), he demanded butterflies. The owl-lady in the *Flair* article is a portrait of a brown owl, painted beautifully, wearing ruby and sapphire necklaces with a full-length, brilliant blue satin glove on a mythical hand. The owl's real face is depicted in a painting beneath, showing through a hole cut in the owl's head. The face is, in fact, partly one of the moths we bought, its wings fully spread so that its black spots become the owl's eyes. (Even these are not the portrait's final eyes for in still another layer beneath are the beautiful pitch black eyes of a Renaissance woman's head!)

This three-dimensional painting is in my home and is a subject of constant amazement. It has two signatures. One is mine, on the moth beneath (to an extent the idea was mine); the other signature is his, bigger than life. It may be the only collaborative painting Dali has ever done; I'm certain his wife Gala didn't approve.

Gala dominated his life to such a degree that when she died, he was in so deep a state of despair he couldn't remain in the house they had created together. He left Port Lligat when it became a tourist haven for a hermit's existence, moving into a feudal ruin, the Castle Pubol (a half hour's drive from Figueras) which he'd originally bought for Gala. One of his paintings of her clinging to a beautiful Dali sword hangs there acting as the patron saint of the castle.

His health has steadily declined. 'Life without Gala is impossible,' he complains. He is now a lonely old man in his mid-eighties, gaunt and ill. In 1984, he fiddled clumsily with the electric switch in his room which he used for summoning a nurse. He set fire to himself and the sheets and badly burnt the house. Covered with severe burns, he nearly died (but it is said that the arrival of the King and Queen of Spain at his bedside hastened his recovery).

In 1974, before he was incapacitated, he set up a Dali Theatre Museum in Figueras, a pink classical building worth a trip to see. Apart from such typical Dali clowning as a Cadillac car given women's breasts for lights (which greets you once past the queue that's always waiting to get in), there is other Dali-inspired nonsense such as a gilded bathtub with a nude mannikin set in a Paris brothel, and a Mae West room with the famous sofa modelled on Mae West's lips. There are more paintings in the museum by a local painter than there are Dalis. They are by one of his best friends, whose own

signature is on them, otherwise they could casually be taken for Dali's – so typical are they of his work, Dali must have considered them a worthwhile parody. He keeps in touch with the museum, even making changes to it, with the help of videos brought to him. His exile hasn't ended his curiosity.

When my husband and I were in Cadaqués we hoped to be able to see him at Pubol but 'no visitors' is the rule.* I wasn't the only 'unwanted' at Pubol. Prince Lucigny-Lucinge and I had talked in Paris about the problem of getting in to see him. The Prince had been asked by Dali to be chairman of his museum; he had accepted but even so he couldn't penetrate Dali's defences. Once when there, the Prince was joined by a crowd of Dali-enthusiasts gathering outside the castle to pay him tribute. The Prince begged Dali to appear. He refused, but suddenly relented and made the magnanimous gesture of appearing at an upstairs window, simply parting the curtains a few inches to show a portion of his face through the slit for just one moment before closing it.

It isn't that he doesn't want to be seen; he insisted another time that he be photographed in bed with a tube in his nose, looking quite hideous. But it is better to remember him as he was with his jet-black, curled, pointed moustache than in his present distressing condition, wearing a heavy satin robe, with his long drooping moustache and white hair flowing below his shoulders around his 'ghastly, gaunt face'.

Though so old and so ill, Dali still seems in 1988 to be in control of his actions. Frustrated and angry over the number of fakes of his prints, he and his artistic advisor, Robert Descharnes, have created a company in Holland to sell the honest ones, after so many fake Dali prints have been forged, mechanically reproduced and a great many sold as originals. In 1987 dozens of dealers were arrested in police raids across the world in an effort to stop them forging his work. A million dollar industry is behind selling so-called 'signed' copies (of 100 of Dali's best paintings, and some of Picasso's and Miró's as well).

Of all the Dali prints sold today, M. Descharnes says only 1 per cent are not fakes, yet some have sold for $1000 each, in sales totalling millions of dollars. One was even sold, it is said, in a shop close to Dali's castle to an innocent buyer for $1500, signed Dali, 1982, although that was two years after Dali had stopped signing any prints.

Dali may really have invented a Dalinian answer to the fakers if it is true that he asked M. Descharnes to set up the Amsterdam firm called Demart Pro Arte. There genuine reproductions are presumably being made, and since Dali is too old to sign them, they will be sold *without* his signature. The false ones may have one, but the honest prints won't. A Dalinian solution indeed.

Dali owes an enormous debt of friendship, which he has never in any way paid, to the American, A. Reynolds Morse, who collected ninety-three of his paintings, 150 drawings and watercolours, and around 2500 reproductions with genuine Dali signatures, plus a huge library. All of this was assembled to create a handsome Salvador Dali Museum in St Petersburg, Florida. Yet to Dali, the Morses were 'just clients . . .'

Mr Morse loyally backed Dali through the crucial years when serious critics belittled his work (Dali never got a favourable review). Mr Morse spent

*After my book appeared, he told the press to 'go to Fleur Cowles – she knows me better than I do'.

huge sums of money to buy the incredible collection, without seeing any of it as an investment. All has been given to the museum.

The museum has nearly 9000 visitors a month, and the Morses had to raise still more money to build a new wing to protect the collection against floods and hurricanes. Such devotion, and yet, three times in September 1987 the Morses stood outside Dali's castle, asking the recluse to see them. The old rogue refused, but when Dali's secretary suggested they go in anyway, the Morses declined. They felt it all too sad.

A Recluse

There is a heavily-wooded, tiny forest somewhere in France where friends of mine live in one of five houses, ranging from miniature châteaux to a huge, lonely Victorian mansion with an unusual air of isolation, tucked away in its midst. Trees protect and draw lines of privacy between all five of the neighbourhood's residents, all of whom are bent on preserving their own solitude. But four of them had one common bond – a longing to know something about the occupant of the fifth house (a building obviously drifting towards dereliction) whose closed shutters hinted at a secret life within, veiled in mystery.

The owner of the Victorian mansion was reputed to be an old lady whom no one had ever seen or met. She didn't shop. She didn't walk her kennel of eleven dogs, which played in the grounds and never left them. Her old, equally uncommunicative retainer ordered her food by telephone from the local shops and must have cooked for the recluse who'd lived in so secluded a fashion for twenty-odd years. Two of my close friends lived next door, separated only by an *allée* of trees from her property.

One day, the drama began. My friend, Monsieur G., on driving off to work in the morning, found an old lady at his gate, weeping copiously. 'Stop! Stop! You must help me,' she cried out. 'My dogs have disappeared. Please help me to find them.' This was said more as a command than a plea. 'They've never gone away before,' she added. (She was about seventy – her figure gone, her hair piled loosely on top of her head; she was dressed completely in black, but even so showed signs of former beauty.)

Armed with details of each dog's size, shape, colour and personality, he promised to find them and went directly to the nearest police station to report their disappearance. He extracted from the police fervent promises that his name would be mentioned to her with the return of each dog.

However, his hopes for a satisfactory explanation of the identity of his mysterious neighbour were dashed soon after he was out of sight of the police station. Wherever the dogs had gone, the call of food was stronger than adventure and the hungry animals returned home of their own volition. When my friend came back later, anxious to report that the police hadn't seen any runaway dogs, he found her gate locked. No one was there then or even the next morning. Nor had he been left a note of thanks. Both he and his wife found their curiosity redoubling. What did go on inside that house?

A month later, the next act unfolded. Monsieur G. once again found the recluse at his gates, this

time on his return from work. She was not in tears but otherwise nothing had changed: the same drab beauty, the same black dress. She was very shy.

'I do owe you my thanks. You were so helpful when I was in trouble last month. Won't you come in and let me give you a cup of tea? I'll walk back and meet you inside.' Unbelievingly, he parked his car to find the door to the strange mansion cautiously being opened. A wordless maid ushered him in. What on earth will I find inside? he wondered. He entered and followed the maid as she opened the door to a sitting room on the left of the vast hall which divided the house into two parts. Left alone he sat down, trying hard to digest his thoughts – first of all congratulating himself on his good luck in getting in at all. He actually was inside!

He had sufficient time to survey the room he had been shown into: beautiful, barely worn, French furniture seemed incongruous inside the chaotic Victorian house. This impression was swiftly accompanied by a final shock! No, he wasn't dreaming; he really did find himself in a strange art museum, surrounded by beautiful paintings hung on every available surface. Incredibly, all the paintings were hung in pairs: an original with its identical copy, side-by-side. *Which was which?*

Instinctively, he decided to make no reference to his hostess about her strange collection. When she sat before him, he composed himself, kept his eyes focused on her alone and did not let them wander to the walls. He talked only about the episode of the lost and found dogs, and his delight that she had turned to him for help. After a bit of small talk over the tea, he bowed out, not once having betrayed his astonishment, not once having glanced around him. When he turned to pay her a final thank you at the front door, he saw the apparent mirage again.

The hall he had passed through so quickly was also covered in twin sets of paintings. Everything from Gainsboroughs to Goyas were hung there; the largest paintings lining the high stairwell.

On the way home he wondered how his wife would react. Would she believe him? Would he ever again get the chance to ask the old lady how she came to possess such a formidable collection. Would his wife deride him for not having done so already? No, he decided, no matter what my wife thinks I know I've done the right thing. Some day we will be friendly enough for me to ask our neighbour to talk. To his astonishment, he found his wife agreed. 'Play it slowly. One day you could become friends. She's opened the door slightly and she'll want to open it a little more soon. She'll be anxious to talk after having had a conversation after so many years of silence and loneliness.'

They were both proven right. He often found his strange new friend at his gate, waving to him and giving him a little nod. At last, one day, she asked him in for another cup of tea. The same procedure followed. He was met by the maid, and this time ushered into the drawing room on the right of the hall. But he knew he wouldn't be able to contain himself because once again he was in a room where beautiful Impressionist paintings hung all around him, each in pairs. The maid, a tea wagon and the old lady followed him, but happily she chose to talk without delay.

'You must be longing to know about my paintings. I trust you because you had the instinct not to mention them when you were here last month. I long desperately, however, to discuss them with someone.' There followed a gush of words; not once did he interrupt her story:

53

Forty-five years ago, I became the mistress of Monsieur X., one of France's greatest connoisseurs and collectors of art. He loved me dearly but he was also deeply attached to his wife. She made their beautiful home famous but he provided a home for me of equal elegance. He spent much of his time with me and tried to make me happy, giving me priceless gifts. He had a need, a mania, to be surrounded by beautiful things.

Every time he bought furniture or china, he tried to find two pieces which were almost identical – one for his wife, one for me. Dealers knew this and helped him assemble the two collections. The complication arose when it came to paintings, but he arranged matters by finding sources who could meticulously copy every original he bought. I never knew how this was done but you must know there are remarkable forgers in Paris. Every painting had its twin – fantastically matched!

His wife died suddenly and we were able to marry. We went, on that happy occasion, to a small château in the south west, where we used to stop on motor trips. It was isolated and full of pleasant memories. He went for his usual walk on the nearby road; I stayed behind because I've always dreaded darkness, a premonition which was hideously accurate that night. He was killed instantly by a motor car racing over the lonely road.

I collapsed. When I could think again, I knew I could never live in Paris or go near a place we had shared together. I knew I needed a huge place because I'd inherited all his possessions, both his wife's and my own. I found this old house and bought it because of its size.

I kept only his favourite things and sold some of the rest – but not the paintings. I wanted every one to come with me. I hung them side by side. . .

Only I know which one he gave to her, which one he gave to me. I shall never again let anyone in to see them. I shall never let them be examined. I cannot bear to find out which one of each pair is real.

Rufino Tamayo

The Mexican painter, Rufino Tamayo, is often called North America's Picasso. He is celebrated and collected all over the Western world after painting for more than fifty years, and being exhibited in most great modern museums (except in England, which has yet to honour his genius).

I've known him and admired his work for more than thirty years and have a great affection for him and his wife, Olga. I met him many, many years ago in New York on his arrival from Mexico (some say that he walked from there). I can still see him in his simple cold-water flat, painting in the bathroom. He had left behind the aunt whose fuel and fruit shop supported him after he became an orphan at eight. Because he hated to talk of his early life, I never broached the subject and know little else.

I collect his work and see him and his wife whenever we are in the same part of the world. Whenever possible, I arrange for a guitar to be

handy. He sings songs which are Mayan in origin (something few can do as the music has never been written down – simply passed on orally by singers through the centuries). Therefore, it is a privilege to be able to listen and to watch his expressive, dignified face when he performs for us, as he does for very few others.

His reputation has made him a millionaire. He spent his money not only on one of the most interesting houses in Mexico City but on building one of its finest museums, later donating his own collection of great paintings to it. After this, he created another museum in Oaxaca for his vast pre-Colombian collection, hung on panels in a beautiful little house with room after room decorated in a different Tamayo colour.

When he started out, he taught. He took a job as head of the Department of Ethnographic Drawing in Mexico's National Museum of Archaeology. His first exhibition was in an empty shop before even one gallery existed in Mexico City. When he got to New York his first exhibition was widely attended and his paintings were quickly bought.

His art is sublime. Though born in a time when such propagandist painters as Rivera, Siqueiros and Orozco were venerated, he never succumbed to their politicizing and nationalism in paint. Instead, he loved pre-Colombian motifs, the evidence of that culture, and the hot, passionate colours of his land. If any painters influenced him, they might have been Braque and Picasso.

He didn't ignore life around him: the war and other eruptions in the world all found their way into his work, although rarely realistically. He could paint beauty, too: I've never seen a more beautiful sizzling pink and red in one painting than in the watermelons he chose to paint. Otherwise, he por-

trayed horror (such as his violent, dislocated figures and his brooding dark animals, ready to attack, like his famous wolf painting). All the time, he moved back and forth between his nightmare visions to beautiful subjects like 'Flower Man' which he painted for me.

His opinion of my work was so important to me that I took a painting suggestion from him much too seriously when he and his wife were visiting us in Sussex. We sat outside on a bench, while I started to paint. I had just finished a background with broad strokes of colour. 'You don't have to paint backgrounds like that!' he said. 'You can dot the colours on or paint in the background after the central subject is done.'

He wasn't criticizing. He was teaching, but I took it that he thought I was painting the wrong way.* I was so stricken with self-doubt that I didn't paint again for two months.

However, as a matter of fact, he thought enough of my flower paintings to write the following introduction to my exhibition catalogue:

> Flowers like the stars from the sky and also from the sea; like savage bloody mouths, like women's eyes. Like snowflakes, like brilliantly coloured gems. Flowers like the tender moon and also the sun; flowers made of dreams, of light, poetry, and love.
>
> *Flowers of Fleur*

On the same occasion, in Sussex, he had a chance to paint something very special. There was unusual activity on our farm, as it was the haymaking

*Although I never have departed from this same method, by the way.

season. 'Everyone works here,' my husband smiled at our guests.

'But I can only paint,' Tamayo replied.

'Never mind, I'll put you to work,' he was told.

My husband put a pot of paint and a two-inch brush in his hands, pointing to the garden gate. 'That needs tidying up,' he explained. It was repainted in quick time by Tamayo and it will be many, many years before anyone has the temerity to paint out the great man's work.

Lucian Freud

Triumphal reviews followed the exhibition of Lucian Freud's work at London's Hayward Gallery early in 1988. His admirers were not surprised. Nor was I.

As early as February 1950, I launched him in the US in *Flair* magazine as 'Freud the Younger'; in fact, that constituted the first recognition he received there. I am intrigued that I used the same words, as I see in print today, to describe his work: 'compulsive' and 'dreamlike'. Seven paintings were reproduced. The darker side of his personality, his exquisite draughtsmanship, his love of nature were all already obvious and have remained unchanged. I reproduced his famous 'Still Life with Lump of Sugar', in which a huge head of a zebra seems to take over the painting; in others he painted a dead rabbit; a 'Scallanian' landscape; a 'Seascape with Sea Holly'; and three portraits of young women in his life. All testified to an almost erotic intensity.

Further important applause for his work in America did not happen until 1987, when it recrossed the Atlantic for an exhibition at Washington DC's foremost gallery, but not before having been dismissed by the Museum of Modern Art in New York City and other American museums. How many red faces are there today, I wonder?

Lucian Freud is a grandson of the father of psychoanalysis, Sigmund Freud. He was born in 1922 in Berlin and lived through the Nazi Brownshirt violence before coming to live in England. His own life style is eccentric enough to have warranted study by his grandfather.

An unplanned act of barter brought me two of his superb drawings and a painting of roses. One is a charming study in black and white of a black cat folded up in a circle on a soft black and white striped sofa. The other is a meticulous pen and ink portrait of Clarendon Crescent in Paddington, where he had his studio. Neither reveal the darker side of his Baudelairean nature. They unexpectedly became mine after Freud had come to New York at the time I published the reproductions of his paintings. Before he went back to England, the penniless painter wanted to buy a wardrobe for his new-born child. I paid for it. On my next trip to London, he repaid his debt with this work.

The *Sunday Telegraph* has written: 'make no mistake: Freud's genius marks him among the greatest British painters of the last 150 years'. He can ask £500,000 for a painting today, it is said.

A Surrealist Experience

In November 1968, I was enjoying myself on one of my regular visits to Brazil – this time after an exhibition of my paintings in the Museum of Modern Art in São Paulo. I longed to stay, but the promise I'd made months before suddenly surfaced in my brain. I had to return to England in time to get to Durham to open the University of Durham's exhibition of Surrealist art. It was a flawless surrealist experience.

The invitation had been so tucked away for six months that I had to refocus my mind. A speech had to be written. It was an important event (few Surrealist exhibitions I've seen have been so complete). Only the best-known work had been asked for by the Student Committee and, amazingly, most was given. I was greatly flattered when they asked for one of my paintings to hang in the same show.

Sudden fog cancelled my flight to Durham; I had just enough time to take the train to the lovely old city. The heating had broken down, but I had been given a warm rug to take as a precaution. The one other person in my carriage looked blue with cold. I felt so guilty wrapped in my cashmere quilt, I impulsively took off my stockings to lend her. They were quickly rolled over her own and we both prayed for Durham to arrive; when it did, I was cold and weary and reasonably apprehensive. Making a speech is always a nerve-wracking event.

Durham's fabled beauty lived up to its reputation. I was met by Professor Allen, who had extended the original invitation; as we crossed the bridge to the town and its remarkable ancient cathedral, my fears slowly faded.

The really unpleasant moments were to follow. At the University hall, I was introduced to a vast student body by Vice-Chancellor Christopherson and I was soon staring at hundreds of faces. I should have been prepared: I'd spent three long years investigating the eccentricities of Surrealists in general (and Salvador Dali in particular). I had been chosen to speak because I'd written his biography. I should have suspected that the students would have Surrealist pranks in mind, and they had.

At my first word, one student shot off a pop gun. Others followed. Others danced noisily in the aisles. 'Music' came from fifty men who had been hired to sit outside the wall of the hall on the college grounds. Each one played an instrument he'd never seen before! The noise was deafening. No one in authority could stop it.

My inclination was to say no more and walk out, but instinct told me to ignore them completely and go on with my speech as if nothing was happening. I'd laboured all weekend to write an amusing one, but it went unheard. When I had finished, I banged on the microphone for silence and though very angry, I smiled and coolly announced, 'You've made a stupid mistake. You should have invited Salvador Dali. He would have enjoyed your pranks. I didn't. And may I make a second point?' I asked. 'Some students think that drugs are a short cut to Surrealism. They are not. You are simply cheating.'

That night, at the home of the embarrassed don, Louis Allen (who had been such a help to me when researching the Dali book), I had a better time. The food was good, the other interesting guests were

57

also university professors. The afternoon was pushed behind until, suddenly, the doorbell rang. Outside a small delegation of students had come to 'apologize to Fleur Cowles'.

Two boys and a girl were deputized to come inside. One asked for an interview, but the two boys on either side of her seemed to be holding up the rigid, ashen-faced girl. Suddenly, her pallor changed to a yellowish green and she fell forward on her face.

'Send me your questions,' I advised as I accepted the professor's invitation to return to his table and other guests.

Diego Giacometti

Alberto Giacometti, the famed sculptor of attenuated, gaunt, dignified women, had a brother, Diego Giacometti, also a sculptor but of a very different sort. Until a few years before his death in July 1985, the aged, retiring Diego, unlike Alberto, was relatively unknown to the public at large until he was commissioned to design furnishing for the new Picasso Museum in Paris. There his inventive, slim, and twisted iron chairs, tables and lighting fixtures were acclaimed, but he had already died two months earlier.

He never did care a snip about recognition. I knew him and collected as many of his objects as I could wrangle from him; it was always a patient game to try to get a piece of his furniture from him. Competition for his work was enormous.

He was generally known as Alberto Giacometti's 'other brother'. He was much more than that; in fact, he was his brother's extra pair of hands, the manual worker who constructed Alberto's armatures for his sculptures and prepared moulds for their casting. He even applied the coats of patina Alberto asked him to add to the bronze as a finish. Their partnership began when they were quite young, living in the Swiss village of Stampa. It continued in Paris until Alberto's death in 1966, nineteen years before Diego.

It was while helping Alberto that the mountain-based Diego started designing his nature-laden furniture, commissioned by canny art collectors, decorators or museums (the Fondation Maeght on the Côte d'Azur was one in particular). His fantasy was delightful. There was a playfulness in even the most austere of his chairs or tables. He loved few things more than animals – dogs, horses, owls, mice, lions – as well as the extraordinary fox he used to keep in his studio in addition to two cats. They all lived inside his quarters and all were incorporated in his bronze objects. (Two of his chairs in my Sussex barn are decorated with lions' heads.)

His apartment was in a back-street area of Paris, the epitome of a *bourgeois* area until it was altered by the construction of new high-rise buildings and banks. The neighbourhood changed, but his style and taste never did. He never forgot wandering over Switzerland's hills in search of animals which, when found, lived with the family, and eventually became elements in his creations. A visit to his studio was a joy.

He created thousands of objects, but they were almost impossible to buy as his inability to meet deadlines was notorious. New orders sometimes took precedence over old ones because of his de-

lighted reaction to new enthusiastic buyers. Only by organizing a steady stream of telephone calls and letters did I get what furniture and sculpture I had commissioned.

His original prices were a few thousand dollars for a chair or a table; they are fifteen to thirty times as much today, but when he was alive money wasn't important to him. Since his death, his ideas have been faithfully adapted and even copied to produce new pieces at reasonable cost, this despite the enormous price his own work now fetches at auction.

The taut simplicity of his furniture and objects makes them look at home anywhere. They survived the clutter of his own studio and the cluttered homes of many of his buyers, but, if you chance to see them in the neo-classical Jupiter salon at the Picasso Museum, they assume a great elegance. They live happily with modern décor or side by side with ancient primitives. They appeal to sophisticates, and – especially – to children. When I look at my own two sculptures and lion-faced chairs I smile.

'Bermuda Blight'

When I moved to England in 1955, four years before I started to paint professionally (or ever thought of doing so), I brought with me my one-and-only amateur painting called 'Bermuda Blight', which I had done as a huge joke when visiting friends in Bermuda. I never even bothered to frame what I thought was a playful exercise in killing time. But it has had a dramatic life.

During the time I was on a trip around the world, a national painting contest was announced in the US, open to any American living anywhere in the country. Thousands competed, under very simple conditions: 1. paintings could not be framed in anything but inch-wide, unpainted, deal wood; 2. their creators' names had to be covered so the judges would never know whose work they were inspecting.

Entirely on her own initiative, my devoted secretary decided to frame and enter 'Bermuda Blight' in the contest: nameless, it wouldn't be embarrassing to me if it were rejected, and if it had any merit, would winning not encourage me to take up painting seriously? she reasoned, When I got to Tokyo I found a telephone message urging me to call her. 'I have news for you,' she blurted out. 'Your painting, "Bermuda Blight", has just been voted second best in a national contest!'

The Summer Show of the Royal Academy was announced soon after I reached London ten years later. Like the American contest, entries are submitted anonymously – so I had little to lose by entering the same painting. It was rejected (second best in the US notwithstanding). Not long afterwards my husband and I bought a house in Sussex and I had 'Bermuda Blight' beautifully framed for a guest bedroom. In the next Summer Exhibition, we decided for fun to let it run the gauntlet again. This time, the expensively framed but very same painting looked good enough to the judges to be hung!

Streeter Blair

I discovered Streeter Blair and persuaded him to paint. He is, in my view, the best of the American Naïve painters (Grandma Moses not excluded). I found him on a trip to Beverly Hills, where he had a shop in which he sold early American furniture. He had been a drummer and even a school principal, though he was illiterate!

He was excessively garrulous, and over two years he told me yarn after yarn about his childhood, his father, grandfather and their lives in a small town in the Mid-West. 'You are talking history,' I told him. '*Write* it.'

'I can't write,' he replied. 'I've never learnt to read or write properly!'

'Then paint these memories,' I insisted. 'Never mind whether or not you think you can paint. Just paint.'

When *Time* magazine wrote of him after his death in a March 1969 issue, they reported that for all his talent, he would have been little noticed except for the happenstance that one day a customer asked him to describe his background. I was that woman. My insistence made him not only rich, but a happier man.

He did as I commanded. He painted his first painting and I bought it (by now I have many others). He revealed himself as an authentic, and finally, a widely acclaimed painter.

He was born in 1888, the son of the owner of the local general store in the little town of Cadmus, Kansas. The chores of his childhood, his life on the farm, the life of the town and its festivals and holiday celebrations in the course of time emerged in the paintings he produced up until he died at the end of 1966. Like other genuine Naïves, perspective meant nothing to him; animals and people ended up in reverse sizes; he was never taught (he sneered at the idea, fortunately). His colour sense was wild and imaginative; he remembered all his travels; he made sure his topography and costumes were right, but he didn't worry about the sizes of people and animals (these could be wrong). He never stopped experimenting.

After I bought his first picture, he began to photograph and mail me copies of all he did, anxiously demanding my opinion and advice. When I moved to England, he was crestfallen. 'Who can I turn to with you across the world?' he asked when I called to say goodbye.

'Send me the slides anyway; I'll reply from London,' I promised.

He started by simply sending me slides, then (in his totally ungrammatical but appealing way) he began to write the story behind each painting. In the end he did write history. After he died, I sent the voluminous collection of his endlessly lengthy letters to the University of California. I hope one day to see the book they said they would like to publish.

The World Fair

The Russians agreed to send their best paintings from the Hermitage in Leningrad to the World Fair in Brussels in the early 60s. The late Louis Camu,

one of Belgium's greatest art enthusiasts and a close friend, was in charge. He asked my husband and me to come over from London as his guests (which meant enjoying the great luxury of driving through the crowded lanes of the Fair grounds in his motorized cart).

The much-touted Russian Hermitage Exhibition was really our principal target, but it had not arrived without a struggle. The Russians had agreed to send some masterpieces. Many were from the stolen collection of a great Jewish merchant, Mr Shchukin, who often used to come to Paris. He became Matisse's first great patron, finding in his canvases the oriental splendour of the Byzantines which he loved, as well as an Islamic abstraction he hadn't seen in other contemporary painters of the Post-Impressionist period. In Picasso's work he found the Islamic influence that came from his Spanish heritage. He felt it in Cézanne's art too, probably because Cézanne lived in Aix, close to North Africa and Spain. His sun-drenched canvases appealed emotionally to the artistic eye of the merchant.

The plan to bring the paintings to Belgium was astonishingly aborted. When the crates arrived and were opened, their recipients' astonishment and rage was uncontrolled. Instead of what they expected, Russia had sent a great many paintings by contemporary painters whose propagandist canvases were the only sort not to subject their creators to prison sentences.

The Russians were instantly informed that they had broken a written promise, that the paintings sent would be re-packed and the Russian pavilion closed. The biggest worry was that there was hardly any time left for the proper paintings to be packed and sent in their place. It was a time of panic; the collection had been publicized in all the World Fair literature.

The Russians officially agreed at once to send the promised collection if a certain percentage of the contemporary work they had also submitted could be shown, too. This was agreed, although only under pressure.

Just one panic-stricken day before the official opening, new crates arrived, worries were over, the paintings were hung, and the world saw this collection of elusive paintings for the first time.

Peggy Guggenheim

An American friend, Peggy Guggenheim, probably served the art of Surrealism more than any single person. She was unusual. She led an unusual life. She had made such an impact on Venetian society that she was dubbed 'The Duchess of Venice' and she lived like one, in a palazzo on the Grand Canal, her elegant gondola moored alongside. A huge horse sculpted by Marino Marini stood at the entrance. This, too, was famous – sometimes infamous – not only for its powerful beauty but for its removable penis, so large it was often necessary to remove it to avoid embarrassment.

She turned her palazzo into a half-museum, half-home. In the garden were glass flowers, a plastic fountain and sculptures, these of reinforced cement. The inside of the palazzo was equally odd, and housed a formidable art collection.

She possessed staggering perspicuity and a bottomless Guggenheim fortune, and used both in a way that shocked the more conservative members of her Long Island family. But she definitely enhanced the reputation of the Surrealist movement and made countless close friends among them: Max Ernst, for instance, was one of her many husbands. She built up one of the world's best private Surrealist collections, finding and fostering some of the most prominent Surrealists, and regularly feeding and financing many others.

She knew her collection had to be donated to a museum when she died; countless museums on both sides of the Atlantic, including London's Tate Gallery, begged it would be bequeathed to them. Once, I thought I had persuaded her to leave it to the Tate, but the conditions she set were quite impossible for any museum to accept. One stated that the entire collection had to be recreated in the exact manner as it had been in her home in Venice, room for room!

In the end, she left the collection and her home to the city of Venice. The public can now see the authentic, eccentric atmosphere in which this remarkable woman lived. Apart from the Magrittes, Ernsts and Dalis and other paintings which crowded those walls, I have always been fascinated by the collection of jewels (mainly designed by her artist friends) which she hung in clusters on the walls next to her bed. I also loved her bottles, vases, urns and ceramics that had also been commissioned by her, designed and signed by the famous.

Her daughter painted in a gay naïve manner and I bought one of the canvases which hung on her mother's wall.

An Artist's Studio

Delacroix once wrote that 'to know a painter you must see him in his studio'. My own greatest experience was to see how Winston Churchill worked but I still retain a clear mental picture of the studios of many other great painters, some of them friends, others whose studios I visited after their deaths. An artist's studio can reveal a lot.

WINSTON CHURCHILL's studio was at Chartwell, which I saw in the early 50s with his greatest friend, the American elder statesman, Bernard Baruch. Before going to his studio, Mr Churchill took Mr Baruch by the hand and led him and me slowly through the house into the garden. Churchill was dressed for comfort in his famous sky-blue siren suit, padding about in gold-initialled, black velvet slippers. I had never realized his complexion was so very white, nor how blue were his eyes.

The studio was long and narrow, lit by windows at the far end. Paints were piled on a narrow refectory table, so neatly they looked unused. A huge globe of the world, the gift of some Americans, was the room's only adornment. It could have been the room of a monk. As we entered we saw two easels standing side by side. On the right hand one was an almost-finished canvas; on the left was a photograph of the same scene, his beloved North Africa, blown up to the same size as his canvas. I was amazed at his candour: few artists I know would admit they copied photographs. He didn't comment, so we looked at each in silence. He obviously enjoyed showing his work. 'It is the way I can bear the strain of things,' he confessed.

Though he was largely self-taught, he was far

from an amateur painter. He ambitiously painted indoor and outdoor scenes (sometimes on the spot). He'd learnt a lot from his friend, Walter Sickert. He must also have loved the Post-Impressionists to have painted in a style that was a tribute to them.

Since I paint in my lap and my studio is wherever I happen to be sitting, whether in Sussex or in Spain, I've always been fascinated by how others do it. Most studio-painters work inside a special studio. What is the atmosphere they create where they work? Is it orderly or disorderly (and is either an integral ingredient in what they produce)? Those studios I've visited remain in my mind's eye and I still see workplaces and paintings as a unit.

The most exciting of all must be PICASSO's, which I know enough about to hope it will be maintained as a shrine to the most able, capricious, versatile painter of his age, who could act like a clown, a matador, a monster, and a very funny comic who kept his props about him.

Reading David Duncan's book, one realizes that Picasso's house and his art were one. Every room was treated as if it were a studio. A swaggering personality prevailed in every inch of the crowded house, museum and cave, at once opulent but messy. In Vallauris, though the home of a millionaire, the house is hardly like the traditional millionaire's elegant villa, but more like a rich local merchant's; for Picasso it was just a studio-home where he demanded and got solitude. The main painting room, his real studio, was crammed with books, pots, and the expressive African objects, masks and tribal art that influenced his work. All manner of clothes were scattered about, amid urns, birds, animals, half-begun sketches, messy palettes, ceramics, plaster casts, huge blank canvases, and everywhere paints and brushes, battered furniture,

rolls of paper, and the huge, white, Stetson cowboy hat that Gary Cooper had given him.

A screech owl lived in Picasso's workshop. Next door was his kiln room where he moulded an endless number of clay cups, saucers and vases. He locked away his Cézannes, Matisses, Modiglianis and Gauguins, plus the work of a great many other painters, in a cupboard. Few in the house were ever allowed to touch anything in it; it has been said he even liked the patterns made by the dirt. He carried a huge key to the studio attached to a cord tied to his belt. However, two living objects did wander about with absolute impunity: his dachshund 'Lump' and his beloved tame goat, who was sometimes tethered in the garden by a short rope. On the kitchen shelves, mingling with dishpans and china were his own valuable Picasso ceramic dishes. The clutter must have been as essential at Vallauris as it was in his Paris studio, which had been built for him by a Modernist architect.

He kept on turning out his creations with furious speed. Picasso squirrelled away his paintings throughout his life. Once, when in Rome, he sent a friend on an errand to Paris to select twenty paintings from his studio for a Rome exhibition. On the floor his friend found nearly forty rows of canvases – at least twenty in each row – representing all Picasso's periods. Yet, a despairing Picasso once sat before a blank canvas, unable to start painting. When his paintings came back from exhibitions, he never bothered to open the crates but stored them away. He never seems to have discarded even a scrap of a drawing nor a scrawl on a bit of paper, not even one of his hieroglyphics. An uncluttered world was not to his taste.

Once, in a *tour de force*, an incredible exercise in skill, he painted an entire bullfight in ink, every

step of the *corrida*, in thirty-five individual designs. (I have the one of a bull standing stock-still, either scrutinizing the bull ring or staring down a matador.) The set includes everything to do with a bullfight, from the huge audiences, the matador, the capes, the *banderilleros* on horseback, to the swords. It took him a few hours to paint.

He sometimes made as many as forty pencil sketches before starting a portrait, and then that was only the beginning; he experimented and experimented, going over a sketch, again and again, until he achieved the rejection of realism he was after. He painted like speed itself. Was this the way he chose to preserve his creative energy, I wonder?

Many years before, when I was still living in America, I saw a television programme about Picasso which I shall never forget. He was shown painting a goat on a huge, upright, transparent piece of glass. On the floor was a bucket of white paint. He had only one brush. Starting with the top of the tail of the goat, he painted a flawless silhouette of the creature, including its whiskers, eyes, everything, and not stopping once before he reached the tail again. Completing it took less than a minute.

Some of his painting phases were lyrical, some wild, some bold, some savage, some daring, some controversial, some playful, but always innovative. He became the most imitated of all modern painters.

JOAN MIRÓ, when in an interview published in 1986, was asked about his inspiration said, 'I never know what I'm going to do – nobody is more surprised than I am at what comes out!'

GEORGES BRAQUE's studio on top of his large Paris house, was busy, but neat, every paintbrush in its jar, the paints stacked neatly (I loved the empty tomato soup tins in which he mixed them). Simple flowers, marguerites in particular, were always there, also plonked in tins. He used to suspend brown, wrapping paper squares against the windows to act like Venetian blinds or light breakers to give him the exact lighting he required.

At his Varengeville farm, the formal world of Paris was absent; instead I found very warm, yellow-orange walls, hung with plates and odd metal designs of the shapes he loved. His wife, married to him for fifty years, was as passionate as he about music, and also kept flowers everywhere. His studio was hidden away; I never saw it, but guessed it was gayer than his sombre one in Paris.

He often painted in pen and ink, then in gouache, then paint; often he used paper cut-outs to represent his forms. He liked to draw in white chalk over the painting in order to subject the forms to scrutiny.

MONET's home in Giverny, France, was lovingly maintained by his son, Michel, and then totally restored by generous donations of American money. Going to visit it has become a pilgrimage for thousands. Outdoors, his garden was in a way his studio. He was, after all, inspired by Japanese prints. Here, painting in quiet seclusion, he continued his Impressionist work. On his green Chinese bridge, he looked down on his waterlilies and saw the irregular masses of changing forms and colours, fertilizers of his imagination. But inside the green-shuttered, peachy-pink house was his real studio. He had started out as a cartoonist!

In his apartment BONNARD's original thick red cloth still hangs over an immense table, which we find in so many of his paintings. His own simple, blue and white-tiled bathroom looked out on a luminous view, the background for so many of his paintings of nudes. The actual white-washed studio

is tiny, like a cell, and most uncomfortable. Coloured portraits and prints of the painters he most admired hang on the walls – such as Monet, Gauguin, Picasso and (revealingly) Vermeer. The patterns he painted were represented by bits of crumpled tin foil, mainly chocolate wrappings, which he used in order to catch the light he wanted to capture. He broke all the rules of colour to do so. He loved large canvases.

MATISSE lived with the bohemians in Paris, on Le Quai St Michel in legendary Montparnasse, where tourists still flock to La Rotonde, Le Dôme and La Coupole *cafés*. It must have seemed a studio commune; the old building housed so many artists.

He used the living room in this conventional apartment as his studio. There he painted nudes; there he became the most celebrated of the 'Fauves', surrounded by his own shiny sculptures, a classical female Greek torso, books on art and artists, and his own paintings displayed on all available walls. The room must have vibrated with youth, life, and colour.

But it was in Nice Matisse finally settled – this time in a handsome Italian-type building. To find him you had to climb two flights of stone steps before you spotted his name on a door set between two frescoes on either side. There was a balcony outside the window, where he could see the sea, the beach and the Old Market. It was here that he created his famous paper cutouts, the jazz paper-patterns which he also reproduced in his paintings. One can almost see him at work there, some-how . . .

RENOIR's studio was constructed outside his home on the Riviera, and was destroyed by a bomb, but his still-untouched villa is a perfect example of the bourgeois elegance he admired and painted. Renoir so often painted the same woman on his canvases I felt I recognized her as the Moroccan-French woman so accurately described in his son, Jean's, novel, *Robert's Story*. She could easily have been the central character in this most readable book on which Jean and I once thought we'd collaborate to write a film script (he in 'broken English' and I to perfect it!).

A friend who visited LÉGER in his studio in Paris told me he found it deep in mountains of dried paint, never touched for years.

VAN GOGH preferred to paint what he *saw* around him, not in a studio. But he also consciously copied the work of other painters, among them Delacroix, Millet and Daumier, and even the prints sent him by his faithful brother, Theo. In penurious moments, he borrowed paints from Monet and Manet.

VAN DONGEN's lavish studio looked like a London Mayfair drawing room.

DERAIN's studio was an epic example of contrast. He worked in an incredibly messy world with the odds and ends of his collector's mania piled all about in disarray, his paintings, masks, broken or cracked sculptures and photographs. VLAMINCK's studio was almost identical.

CHAGALL also lived amid a pile of paints, pens and pencils. His studio, when he was at work painting, was a world where he externalized his overpowering private dream-mirages, his mind flying through the air just like his painted peasant men and women. Flowers and beasts hover, float and soar above his earth, within his poetic paintings.

GEORGES MATHIEU is undoubtedly the greatest exponent of action painting alive today (and one of

Dali's close friends). This eccentric American lives in great style in Paris (with his Rolls–Royce), but has little need for a studio. He once described to me how he prepared for a show in Tokyo: he hired a garage in order to hang all his unpainted canvases on the wall. Using huge tubes of paint, he dashed from canvas to canvas, squirting thick paint on each as he flew about the room. This he repeated with ten or twelve colours, until he felt his wildly abstract images were complete. His exhibitions are always sell-outs, including the paintings fifteen or twenty feet long.

I've known him for years. He was a great help to me when I was researching Dali-data for my book, and we've remained friends. When he had his first exhibition in London, I asked a few friends in to meet the eccentric man before the preview. He never stopped looking around my drawing room *intently*. When we got to his gallery, he halted me before the largest painting on show and announced, 'This is for you!' I was stunned; not only had I no wall big enough to hang it on, but the huge violently coloured, action-abstract would have shrieked out in pain in my eighteenth-century room.

I thanked him profusely for the gift but tried to explain, with great care, that it was too large. 'Not at all,' he insisted, 'I've examined your room and know exactly where to hang it.' It was difficult to continue to decline to take it, but I finally prevailed. The next day it sold for £40,000.

66

How I Paint

There are probably few painters (other than the Chinese who paint their scrolls on a flat surface) who use no easel, use no palette and have no studio. The absence of all three describes in very few words how I paint.

My lap replaces an easel; the tubes of paint are in themselves my palette (I paint directly from them); my library couch in Sussex is my studio. I paint with either tubes or jars of acrylic paint,* gathered up by my brush as a bow would the strings of a violin.

My studio is a windowed, dark-chocolate brown room where light comes inside in differing ways and amounts during the day. When the sun does give up, an angle-light is put on a little table just behind the couch at my left shoulder. Sunlight or not, this is how I continue to paint into the night, except for meals.

A traditional studio would be an anomaly. I never need solitude to work. Instead, I prefer to have friends around. I like talk. And I like companionship, hence I'm never bothered by the presence of others. The vision of a truly great artist in words, Chekhov, sometimes comes to mind and amuses me. 'He could sit at a table, amid the din of a large impoverished family, ignoring voices and footsteps – in order to concentrate on the scratch of his pen.'

Interferences? There just aren't any. No guest

*See p. 69.

has ever asked why I did or didn't do something, or made a suggestion. The gods are kind; they let me work. Conversations with guests never seem to interrupt my stream of memories. I just sit there and paint, non-stop. One critic described my method this way: 'While she paints, she orders the menus, directs traffic and saves the world.'

Discipline rules my life, and helps me cope with my heavy schedule: four days in London, three in Sussex. Every Friday morning, I see my household and gardening staff and then sit down to paint until Sunday evening (guests arrive for Saturday lunch, not before). My London four days are desk-days, in which I deal with a large correspondence (I'm an old-fashioned letter writer), manage our three homes and, best of all, work on a book.

I never think about or compose a painting in advance (in my mind or on paper). I never draw. I never use a model or copy a thing. I paint what has been packed away in my computer-memory, those animals, flowers and scenes which wait for my brush to give them life. I write the same way; I never make notes and do not keep a diary. I depend on recall after I have selected what I want to remember. Everything else fades quickly away.

Flowers and animals have always been imprinted on my mind. As a little girl I once wrote every morning about a discovery I had made the previous day in order to keep it 'on call': the way butterflies' wings differ in colour on the outside and inside; the way frost changes the colour of leaves; how a stem is attached to a flower; where a bee's wings are fixed to its fat body. Such treasures have never disappeared from my mind. I was born with curiosity and like to pass this passion on to my nine god-children.

I once pretended to live under the spreading arms of a mulberry bush and now I paint it. I made other mental notes: how a jungle cat stared at me in a zoo; how a vine entangled itself aimlessly but with the purpose of growing. When I first began to paint, I tested my memory in a novel way: I would hold a real flower in my left hand for five or ten minutes, examining every detail minutely. The next day I'd hold up my empty left hand and paint the flower that *had* been there.

Miró developed his instinctual memory in an equally personal way by holding an object behind his back, then reproducing it without having had more than a fleeting glance at it. Chagall, in his book *Ma Vie* written in 1931, said *'Les fleurs sont inventées'*. And did Degas really paint flowers by not looking at them?

I've always wanted to paint, but felt I should try to write instead after I began to read adult literature. Willa Cather and Katherine Mansfield were my idols; I yearned to write as they did. Instead, I ended up as Associate Editor of *Look* magazine and Editor-in-Chief of *Flair*, and suppressed all notions of painting. In fact, as an editor, I had to be so critical of the hundreds of paintings that came before me to pass scrutiny for possible editorial inclusion that I decided I could never pass my own muster. It was only when I gave up vanity and asked myself why it mattered how I painted, as long as I could paint at all, that I had the courage to paint. Soon the jungle cats and over-size flowers appeared.

I am continually asked why I paint these jungle beasts. I don't think there is anything more to it than the vivid memory I have of them as a child at zoos, but my husband has a different answer and I agree that he's partially right. He once gave me an Abyssinian cat; a most unlawful act as the

eighteenth-century, national monument in which we live in London still heeds its ancient rules: no animals or children are allowed. We gave the cat away very soon but the sleek animal stayed long enough for me to absorb him and his ways in my mind's eye. He used our home as a jungle, prowling (never strolling) through and around the furniture, and never in a straight line. He would fly to the top of a high armoire in our bedroom, to stare down at me intently. Sometimes he would jump into my office wastebasket to continue to stare, a friendly beast but no house cat, he. I obviously did mentally photograph his jumps, his walk and his eyes.

I often see him in one of my paintings, camouflaged in stripes or dots. I saw him in one painting seated with another tiger – the tigers in a rowboat (see p. 74) – the boat tucked into the reeds alongside an African lake (this was bought by Princess Grace). In another he is hiding under the leaves of a great crowded bouquet in a basket on a beach.

My work increases in size steadily, principally because collectors now prefer larger paintings. This can be difficult, but I still paint them in my lap. The only time I had to puzzle out *how* was when I painted a three-panel screen, six foot in height. First, I had to position it on the only large surface in my Sussex home, the top of a large desk-high cupboard in the kitchen-annexe. I could then paint the entire seven-foot wide background before taking the panels apart to paint them individually.

One at a time, I perched the top end of each wooden section on two pillows on the coffee-table before me and put a fat pillow in my lap to take the weight. It was impossible to reach the top of the panels so, in one instance, when I decided to perch a cheetah on top of a tall flower-tree, I had to invert the panel and paint the animal upside down. Turned upright again, the animal survived the experience, looking fine.

I have grown so accustomed to my couch in Sussex (which I usurped as 'my seat') that it took years for me to recreate a suitable place to paint in my restored castle in Spain. There is no soft couch in the cloister where we practically live in the heat of the summer. So I use a bench, which is part of the dining area, and have learnt to park my paints to my left, my brushes to my right, and carry on.

My paintings seem to make people happy. They represent my private world, a peaceful one that rejects the unpleasant, the ugly and the frightening, and dredges up no horrible dreams. I've read that I've been influenced by Dali. Certainly not. He has even been called something I'm not: a Surrealist. I have been officially classified with them, however, when my paintings were exhibited in the Surrealist wing of the 1966 Biennial in São Paulo, Brazil (together with such others as Magritte, Delvaux, Max Ernst and Dali). However, a *Time* magazine critic pointed to my nine paintings as 'the innocent among the wicked'. Nor am I, as often is claimed, influenced by the Orient. Wrong. I could never achieve their wet-brush Impressionism.

All my paintings are inhabited, instead, by carefully painted peaceful animals living harmoniously with flowers. My animals bare no fangs, never are poised to leap for a kill and, though never fearsome, are never coy. They have been called naïve, surreal, realistic, literary and illustrative, and certainly have never been confused with abstract or conceptual art, or with experimentation with organic or industrial material. I paint with paint alone and no other medium. I have sold every painting I've done, except for the few I've 'stolen'

for my own homes. My fortieth one-man show took place in Tokyo early in the Spring of 1988.*

In May of 1987, I ventured into a new world when one of the finest porcelain shops in the world, Goode of London, launched my porcelain animals and flowers. Years before, I had been commissioned by Limoges in France to design a line of dinnerware for them and greatly enjoyed not only the experience but the applause, so when I was asked to embark on this new endeavour, I was happy to accept.

Fortunately, they were made by a superb company, Border Fine Arts of Scotland, who created identical bone china reproductions of my jungle cats and flowers. Their hopes and standards are the same as mine. The animals are just as they were painted on canvas; they still clutch the oversize but essential flowers which often are completely out-of-scale. A separate collection of flowers on their own also have tiny jungle cats which perch on stems, leaves or petals. The animal figurines are in limited editions, but the flowers will continue to be produced without limit, followed by new designs for table porcelain in the future, which will allow me to go from canvas to porcelain tableware once more.

There are things I don't do that other painters do (they are all found in many of the world's most admired paintings): I don't use a sponge to create backgrounds. I don't use cotton wool, dipped in white, to make clouds. I don't use very liquid paint to dribble over canvas. I don't use watercolours. I don't dip paper in water to let the water trace a form or shape of its own, nor draw on it with ink when slightly wet to make a delicate abstraction. I don't

*When I had exhibitions in Tokyo, Kyoto and Kenawara in Japan, again it was said my work has been influenced by the East. Not true, but very flattering in any case.

finger paint. I don't use one medium on top of another (paint over pastel, for instance).

There are other 'no's' of mine which were successfully used by the greatest painters. Braque used to use strong, smooth canvases and rub a pumice stone over them to get what he called a beautiful texture. Joan Miró used to clean his oil brushes on paper intended for future watercolour sketches to obtain a background in that way. Another painter I know used fixative on pastels so that they looked like tempera paintings.

I'm often asked why I use acrylic paints and when I started to do so. It was unplanned, the result of a delightful accident. During my second New York City exhibition in 1962, I noticed a man, who came in frequently to study each painting, slowly moving around the exhibition. I was flattered and bemused. How to explain his actions?

At that time I used to paint with gouache paints, which, being somewhat perishable, I always had to frame under glass. One day the mysterious observer came up to me and asked, 'Why do you use glass on your paintings? I admire them very much, but it is hard to see them through the glare of the glass?'

'I must either frame them this way or varnish them to protect them; I've chosen to use glass,' I replied.

'But you should use modern paints instead,' he pointed out. 'Today's medium is plastic. Learn to use them instead. They need no glass. The colours are permanent.'

'I've never seen (or recognized) plastic paints or tried to use them, although I do know that Rufino Tamayo uses them,' I replied. 'Nor do I know how to use them or where to find them.'

'If you'll come with me, I'll take you to the right shop,' he remarked. 'I want to help you because

your work deserves the best. When will you be free?'

For an instant I wavered. Who was this odd man? Where would he take me? I sensed he was being incredibly kind so I gave him my address and went on, 'I'll meet you outside the door at nine-thirty tomorrow morning.' I never really expected him to appear, but he was there on the sidewalk at the proposed hour.

We walked down Fifth Avenue together. I asked him over and over to tell me his name. 'I, too, am a painter. My name doesn't matter,' was all he would say. We turned next on to 45th Street where we found a huge art shop; there I found the acrylic paints and selected every colour I thought I might use. They were shipped overseas to me in London.

Meanwhile, while we walked, he explained about the paint and how fast it dries: 'This is good; you never need to wait for it to dry as you would if you used oils for your next step. It is obvious that you love detail, which means you must work steadily. The paint will dry so fast you can put your hands on the painting immediately, but all your brushes must be quickly washed in water every few minutes or they, too, will dry so fast you won't ever be able to use them again. You'll never again need to use glass to protect your paintings or varnish them. You can determine how mat or how glossy you want your surface to be by using the milk-like acrylic medium. You will never use anything else after you begin with acrylics,' he warned.

Years later, reading *Arts* magazine, I saw a four-page article about this friendly man. He is one of the best known of the New York School, but to me he will always be a volunteer friend. At last I could properly thank him, but when I did he made me promise not to identify him. 'I don't really want credit,' he insisted. I've used acrylics for almost twenty years and believe that painting with them gives my work permanency.

I start by covering the surface of a board or canvas with a background. Sometimes it is a sky and sand or sea, or just a sun in the sky, or a sunset. Sometimes it will be a mixture of many shades of greens which will become the background to the myriad leaves I then paint to turn it into a forest. Sometimes it is a lake, or a sky striped by masses of weeds and wild flowers . . . I've never looked back.

PAINTINGS BY
FLEUR COWLES

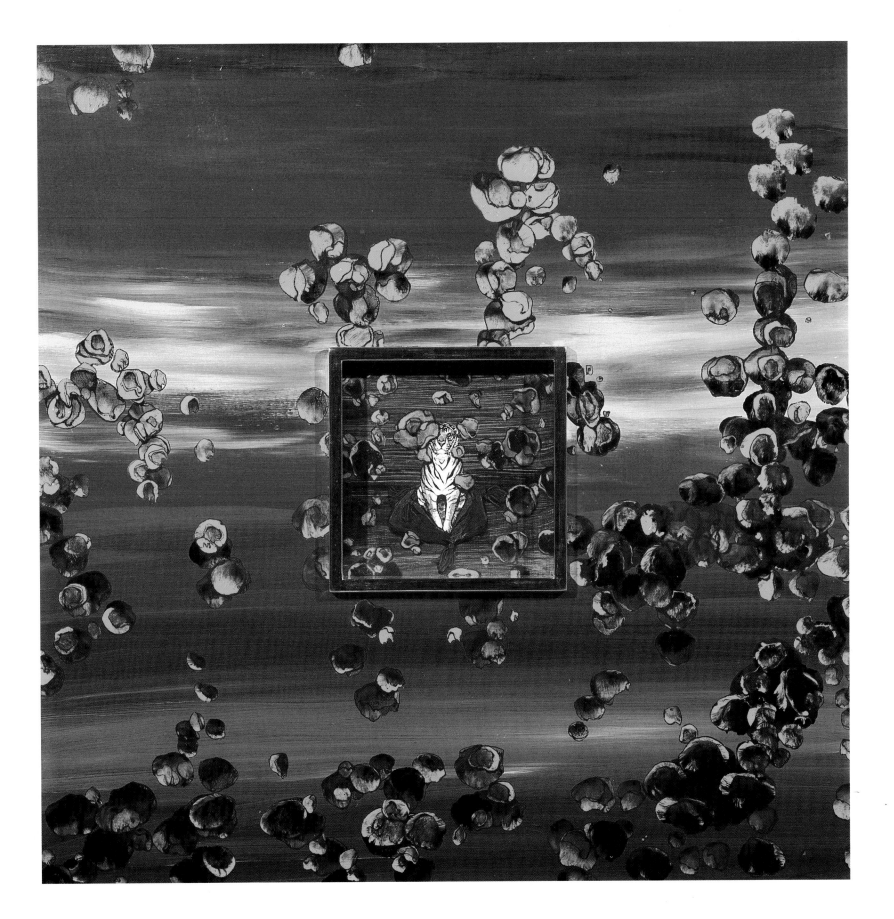

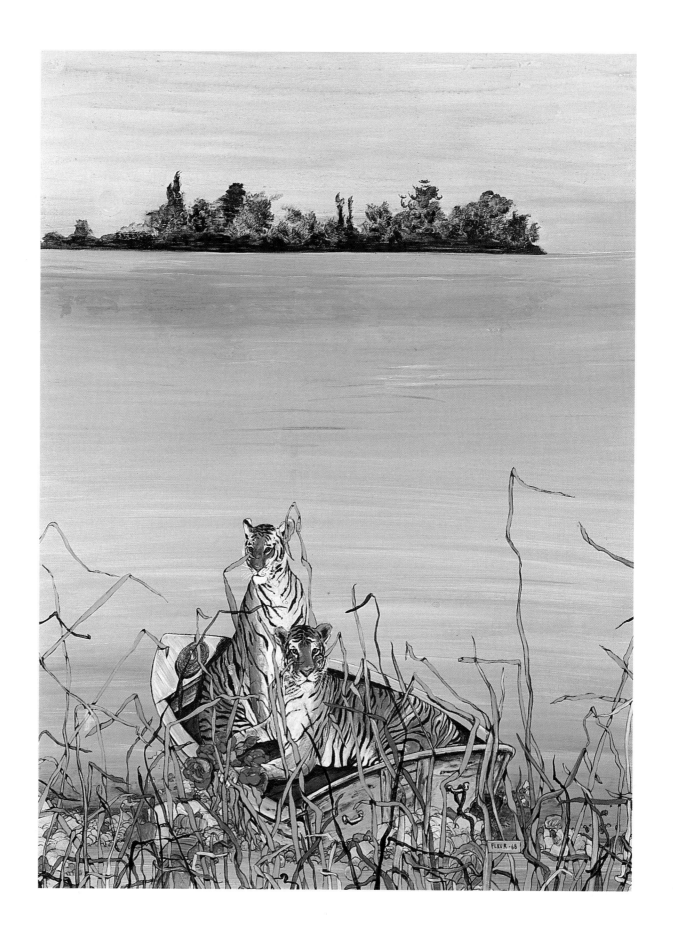

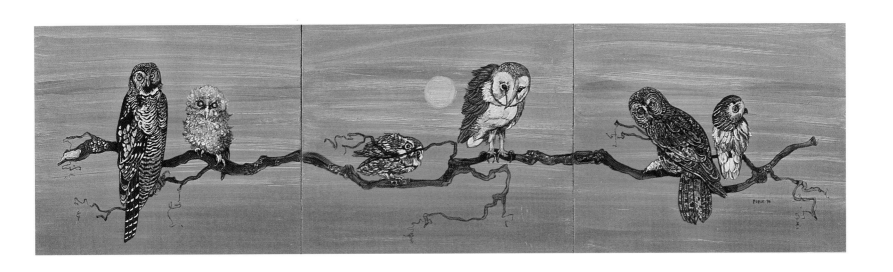

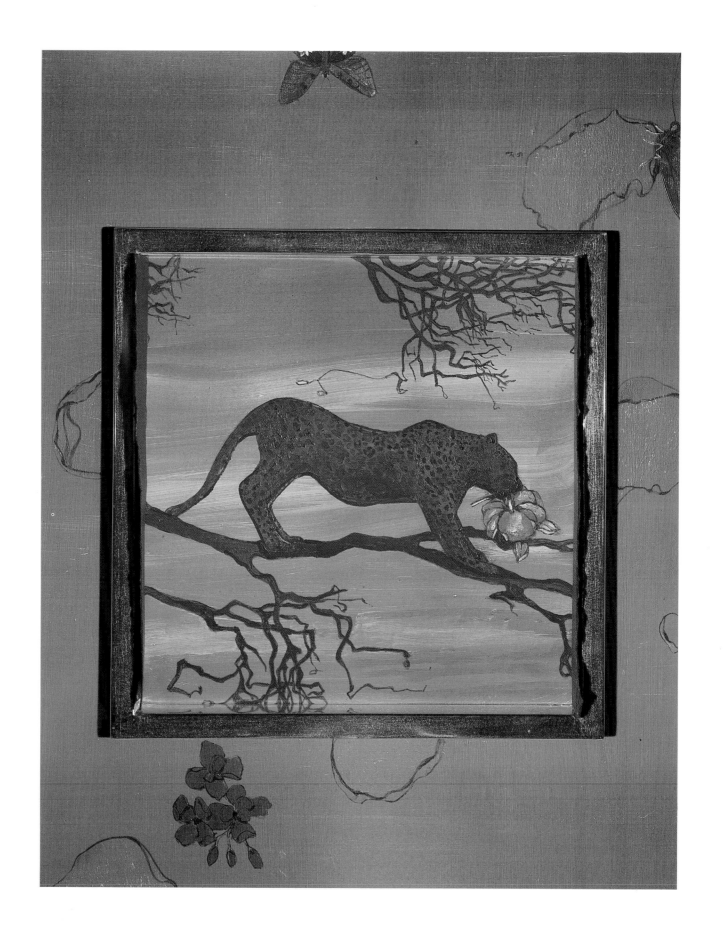

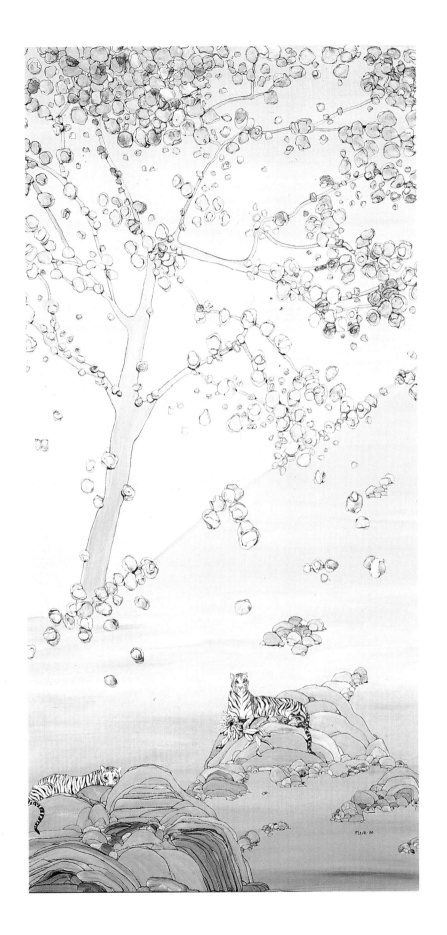

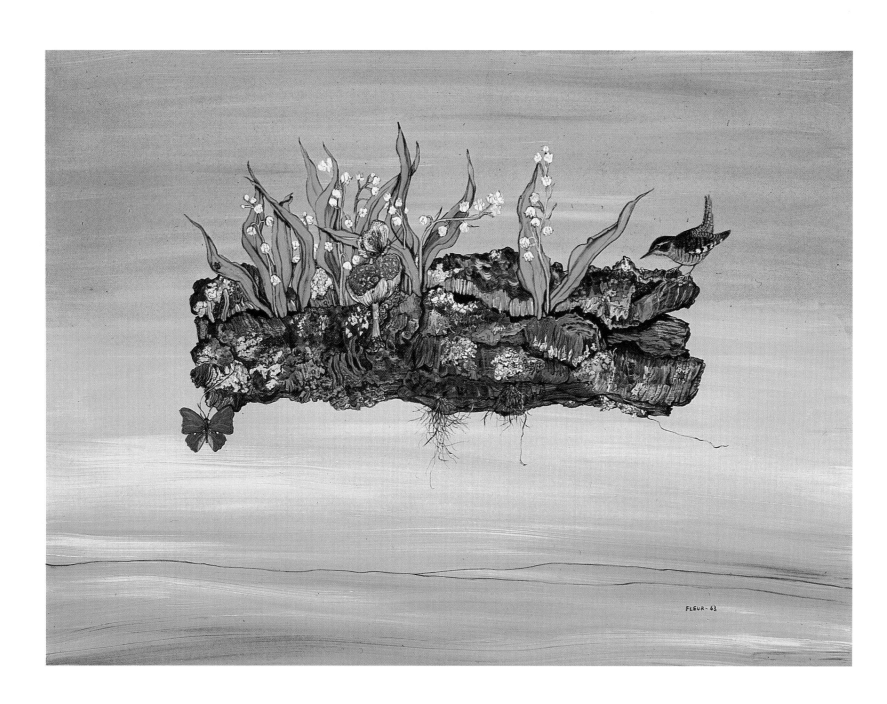

FLEUR- 63

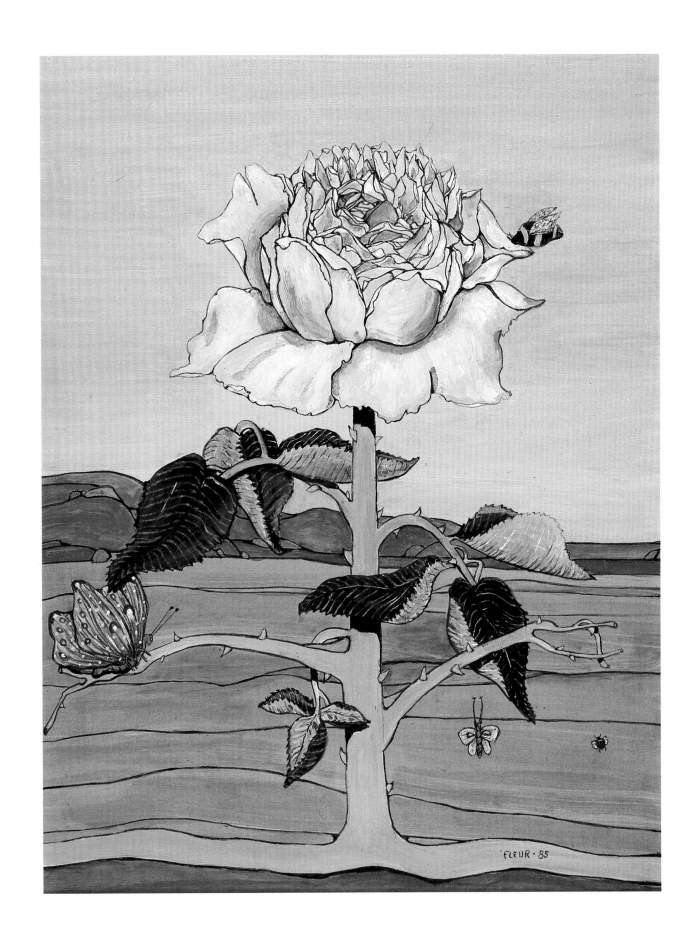

FLEUR - 68

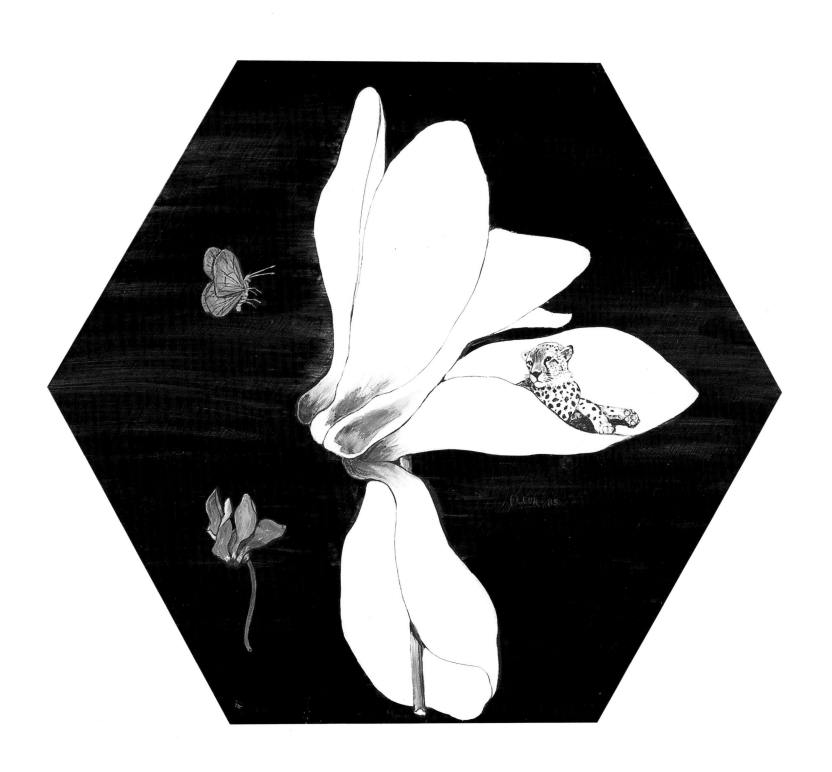

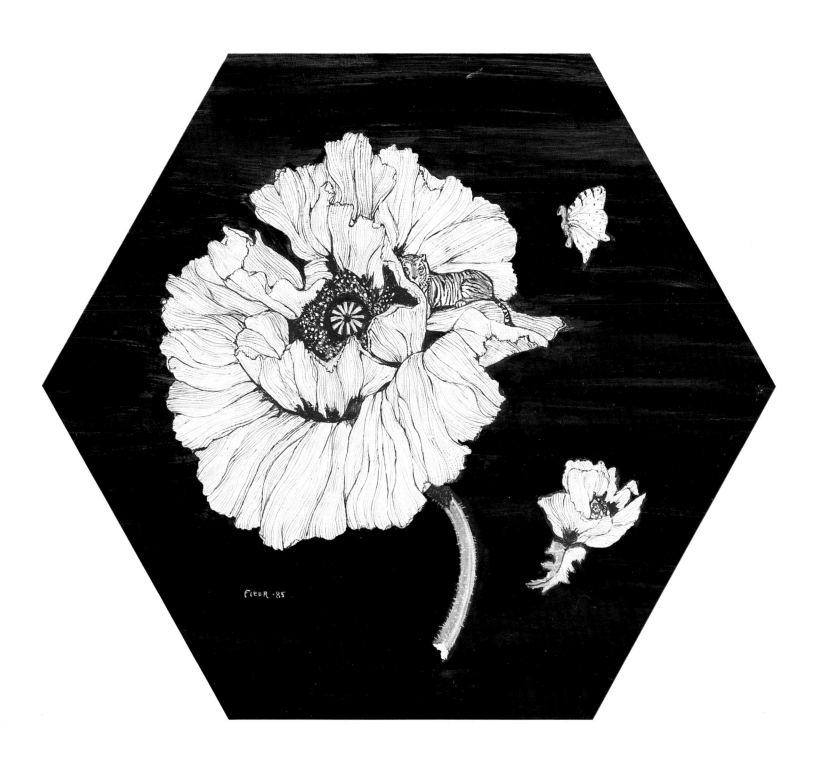

FLEUR ·85

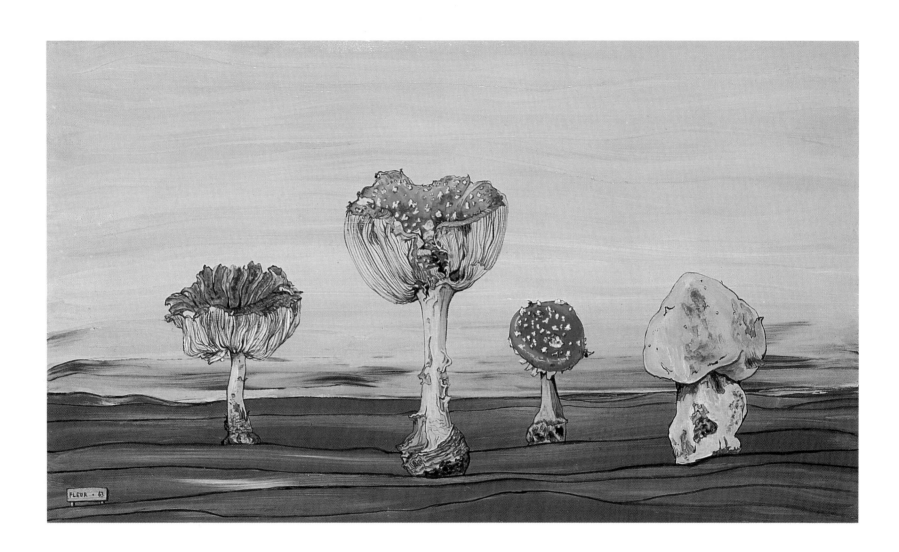

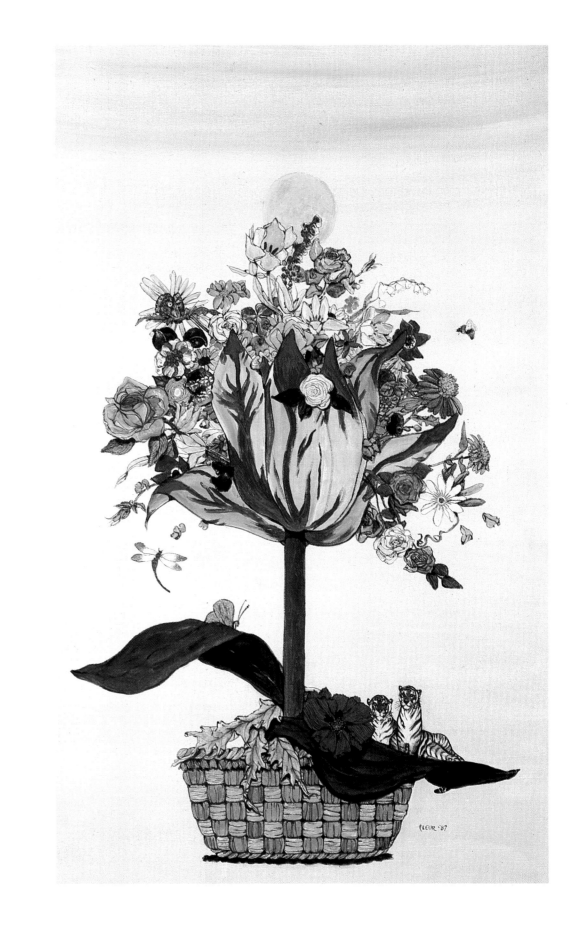

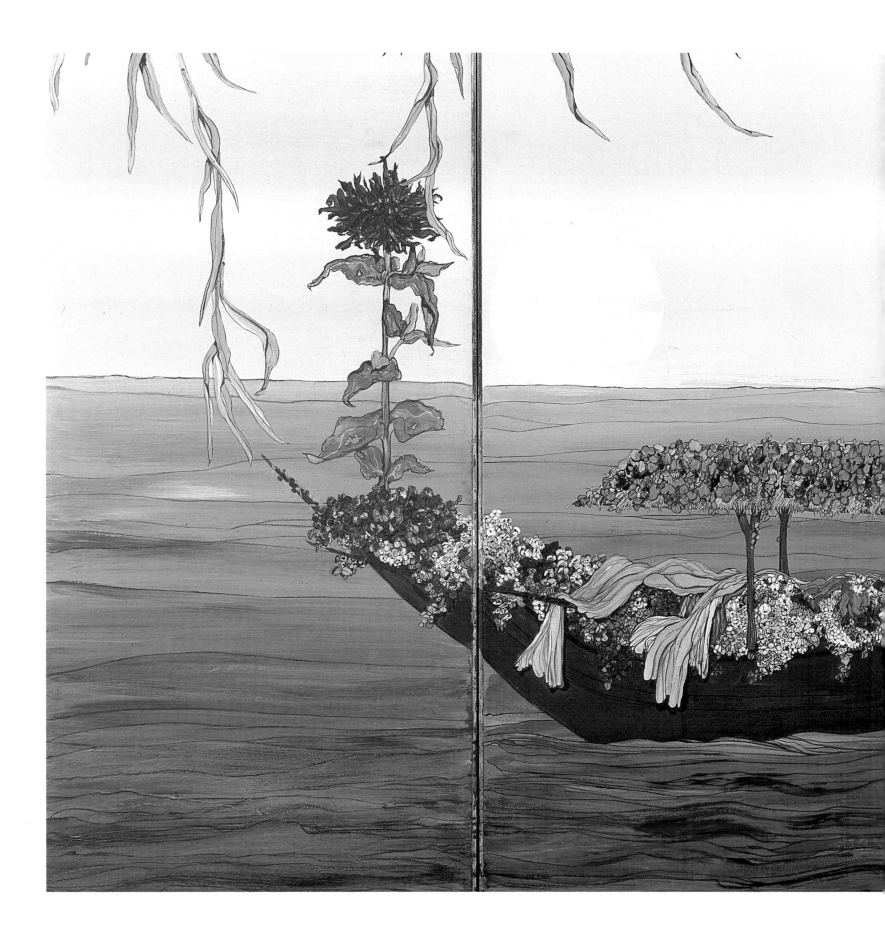

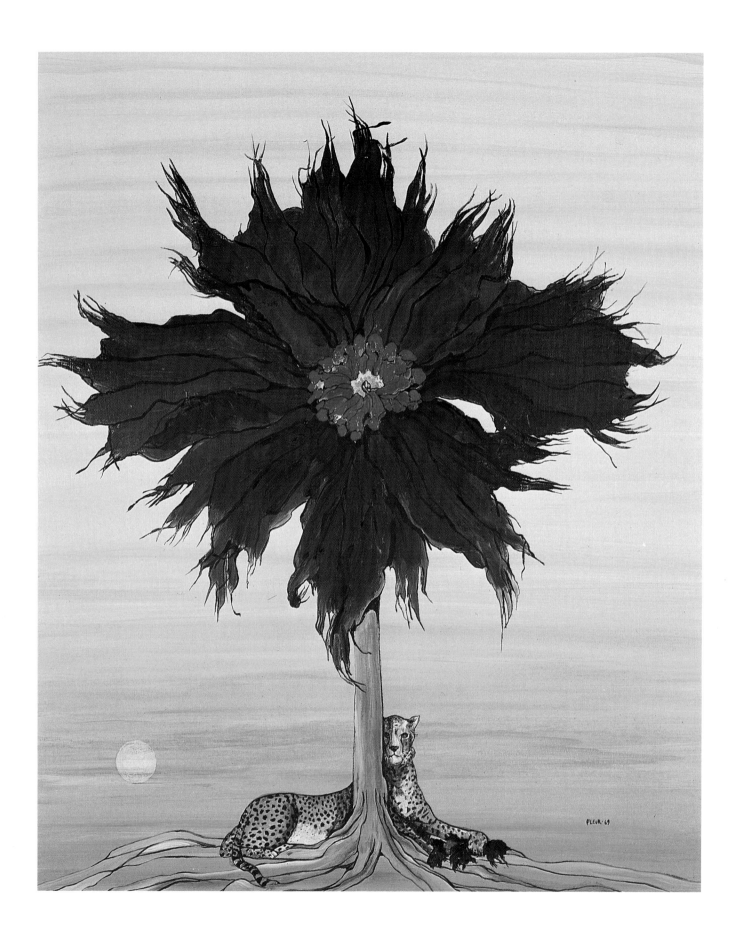

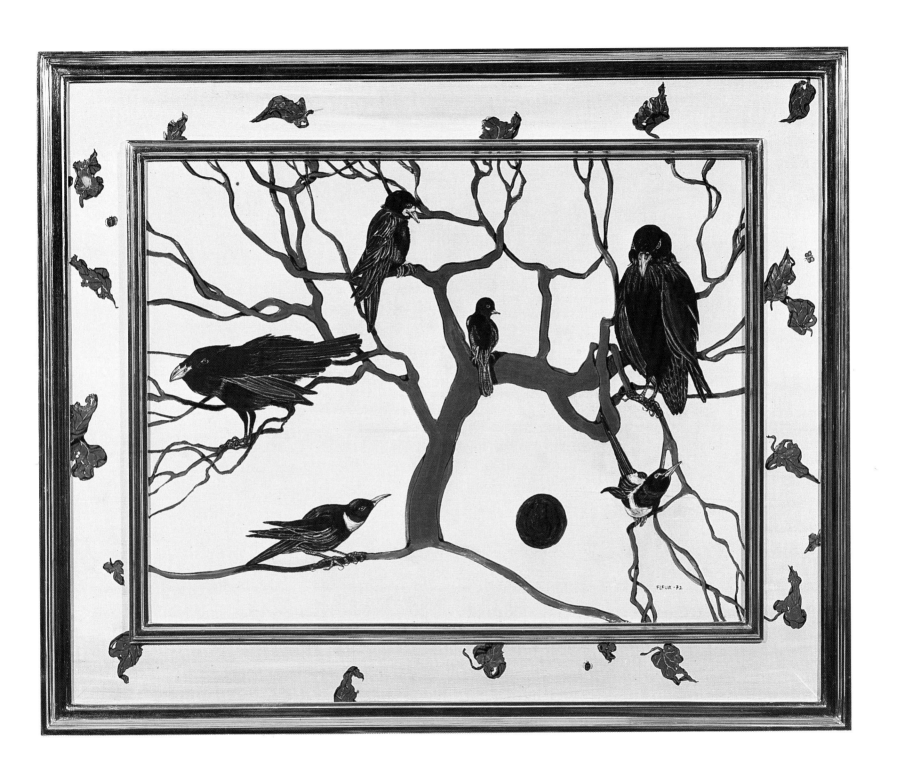

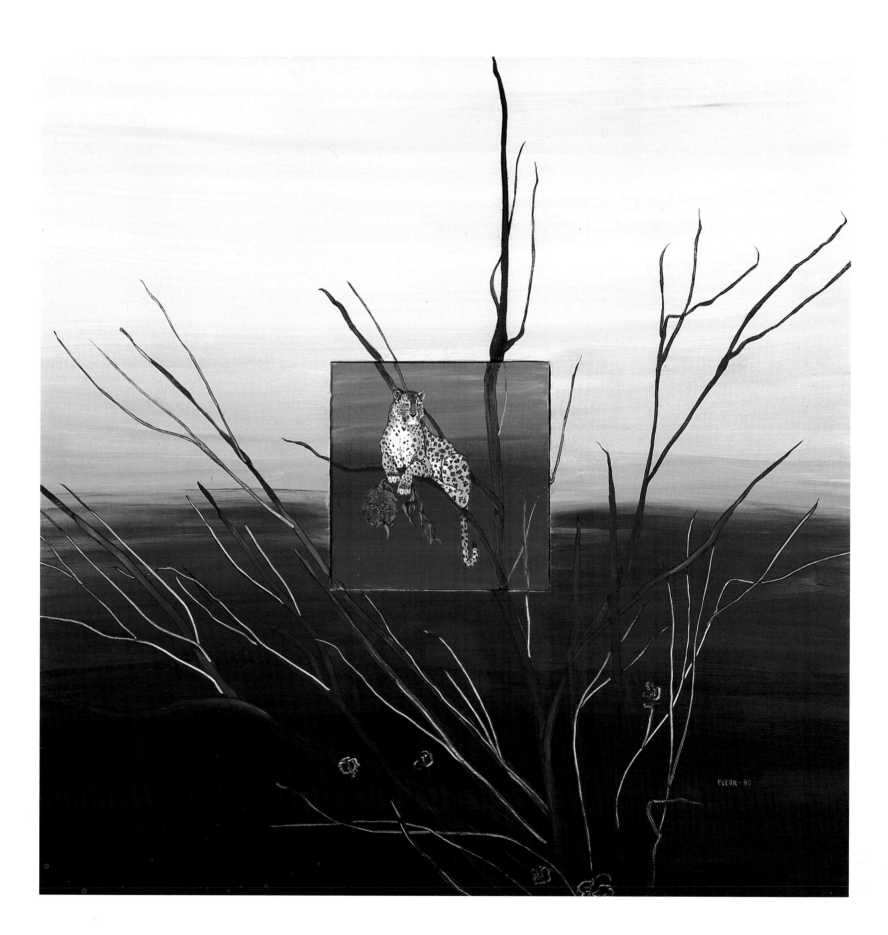

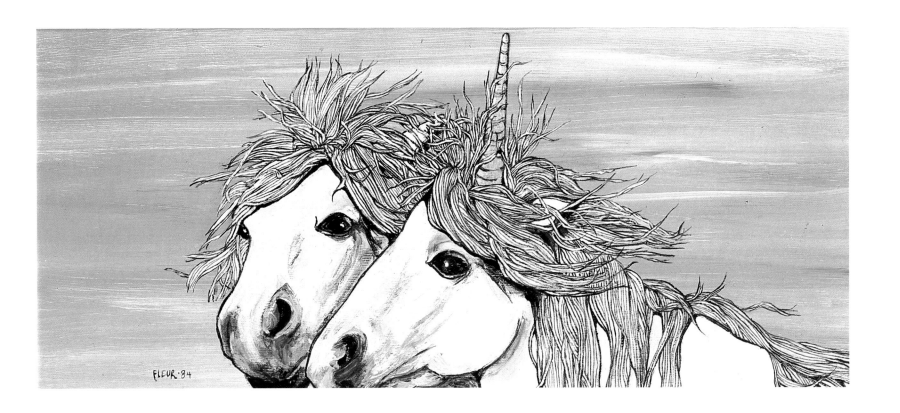

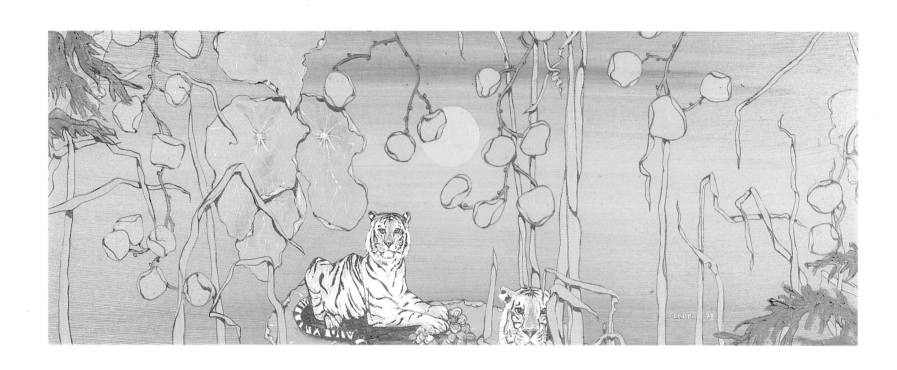

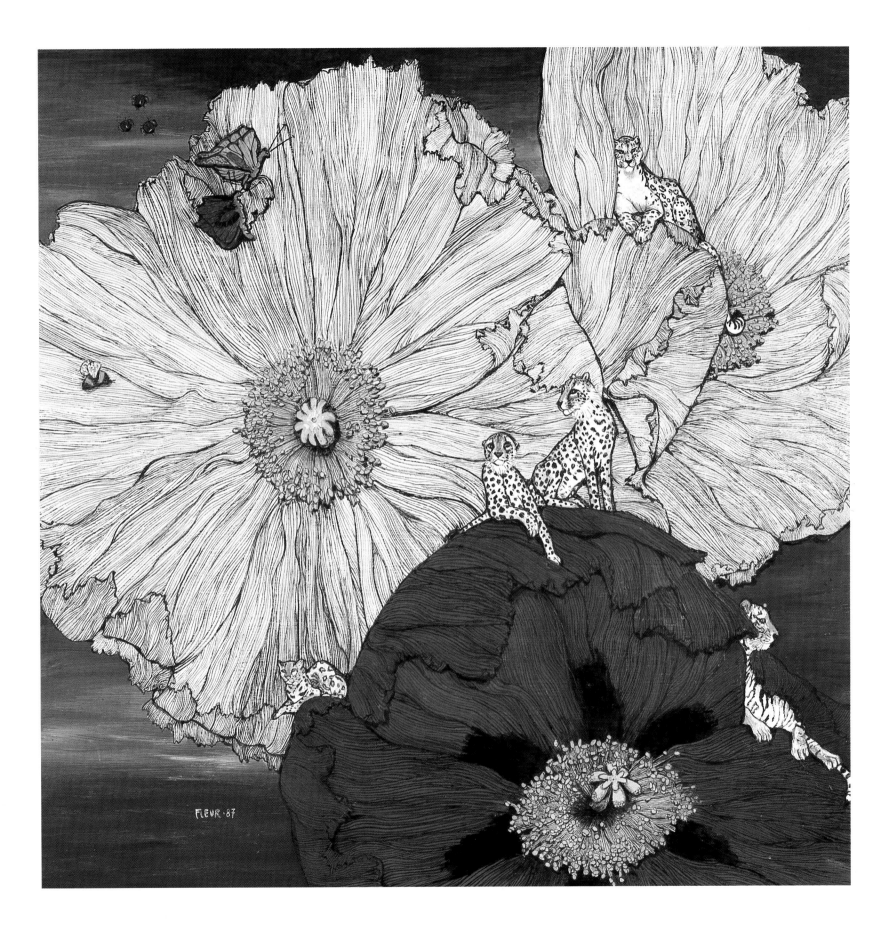
FLEUR ·87

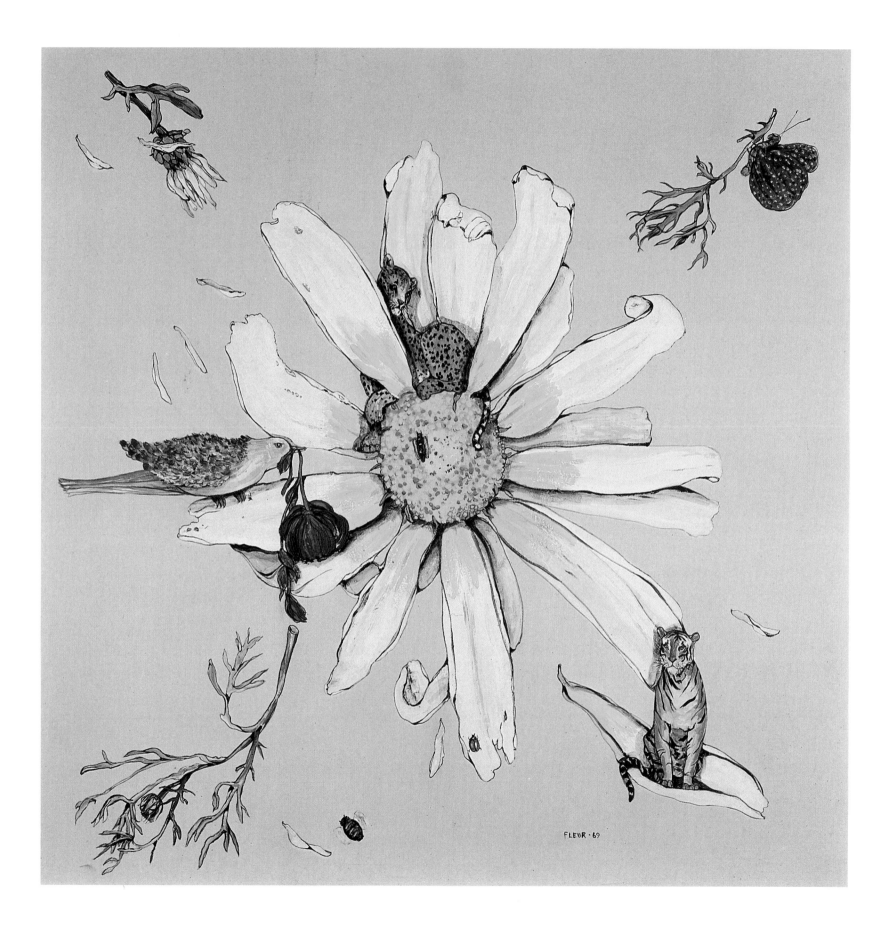

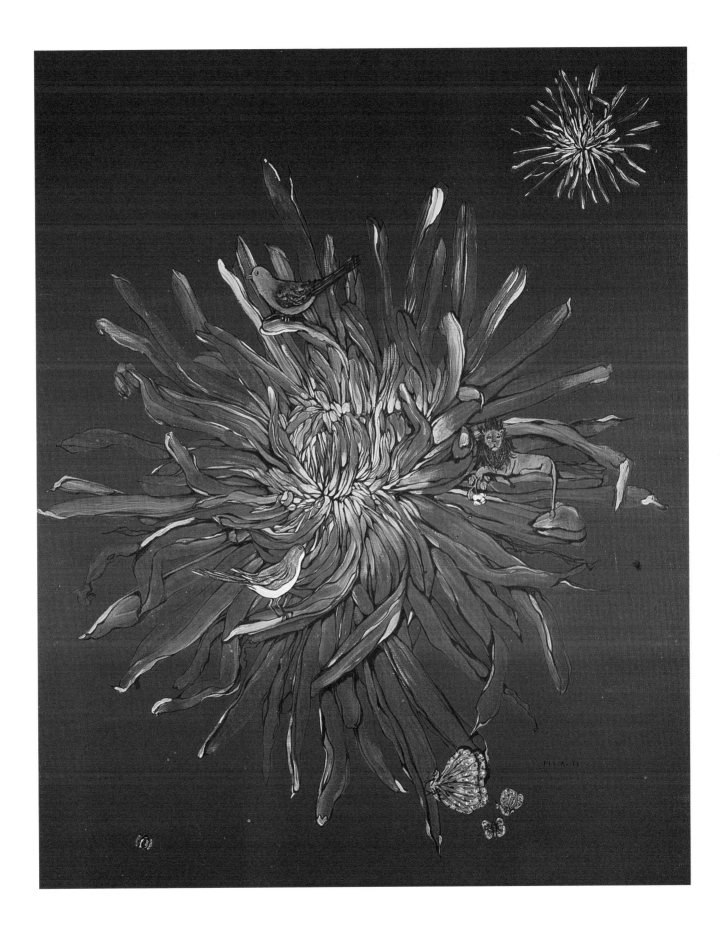

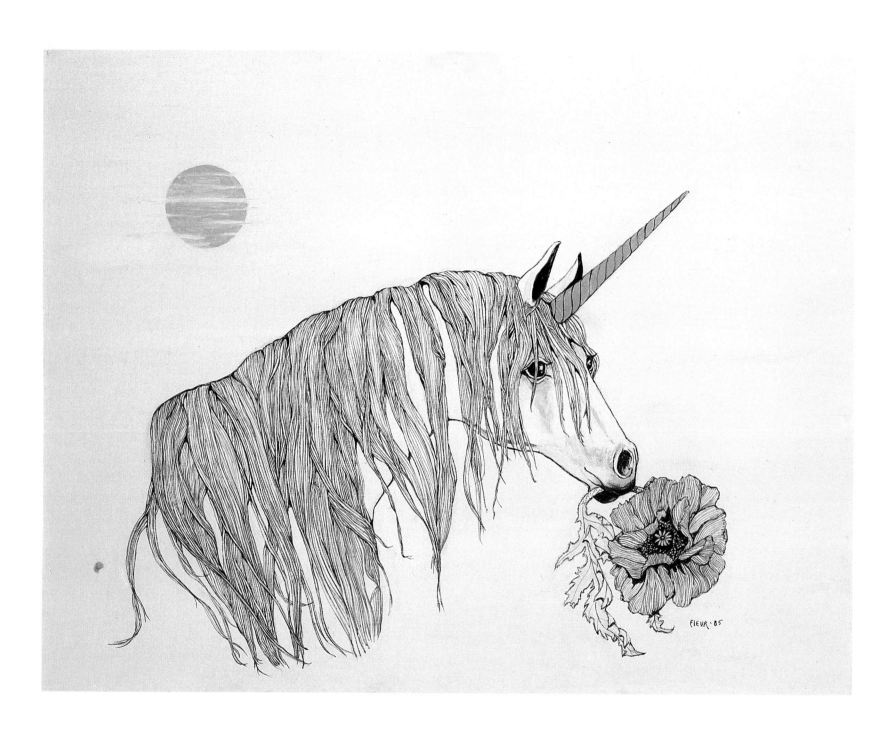

FLEUR '85

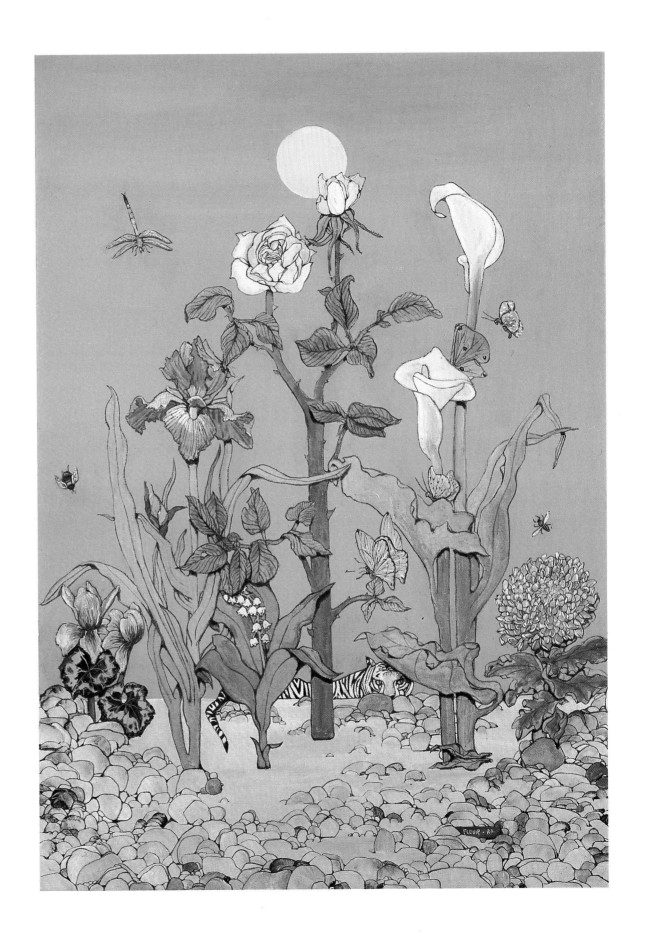

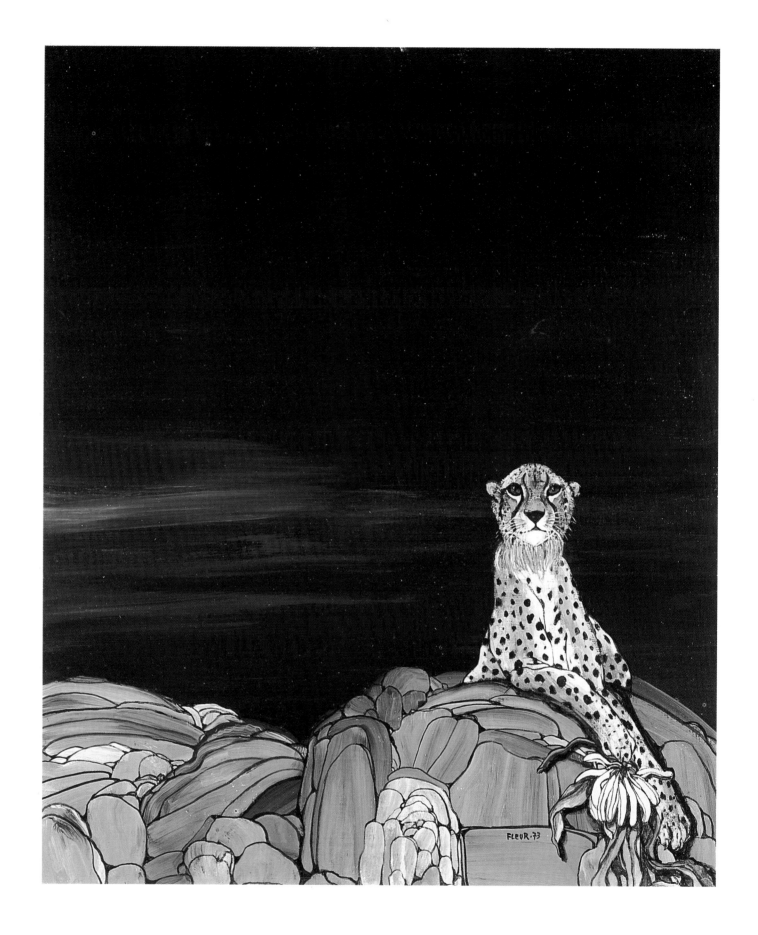

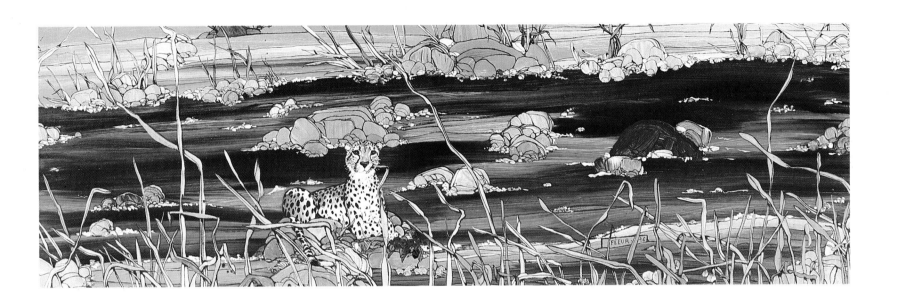

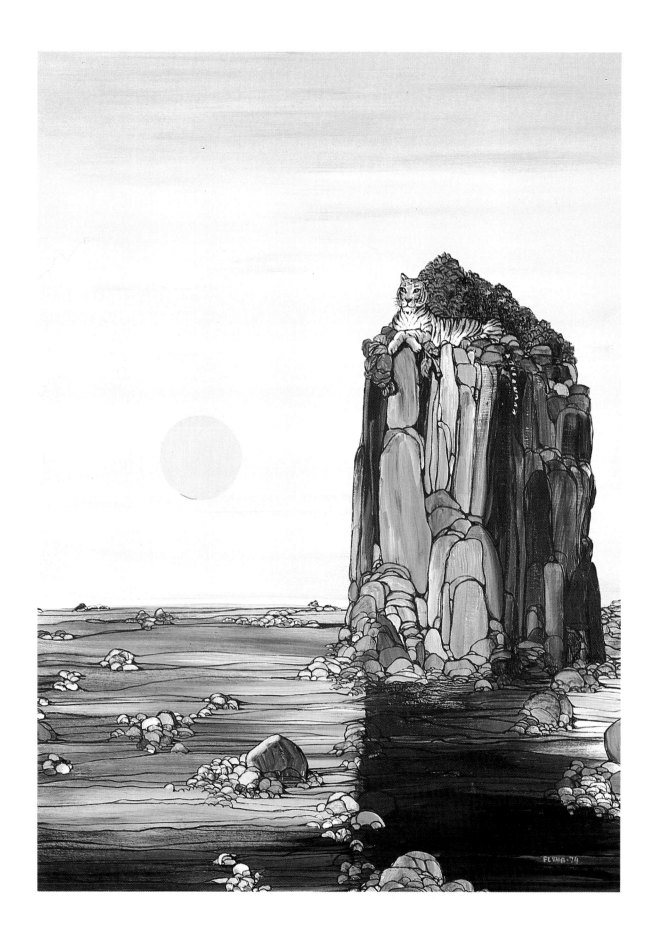

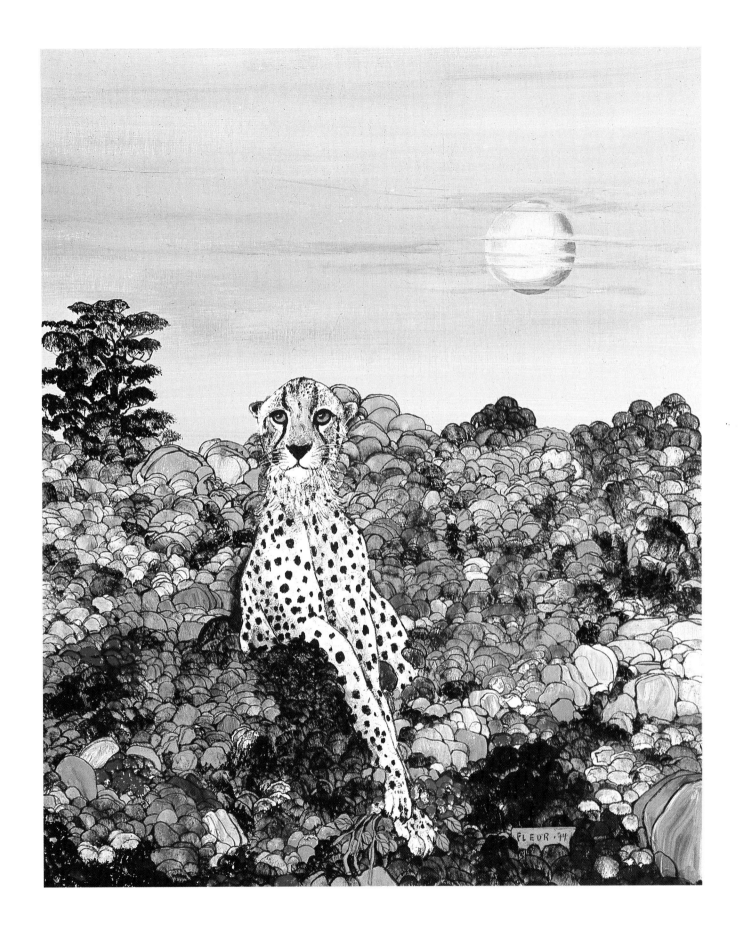

FLEUR '83

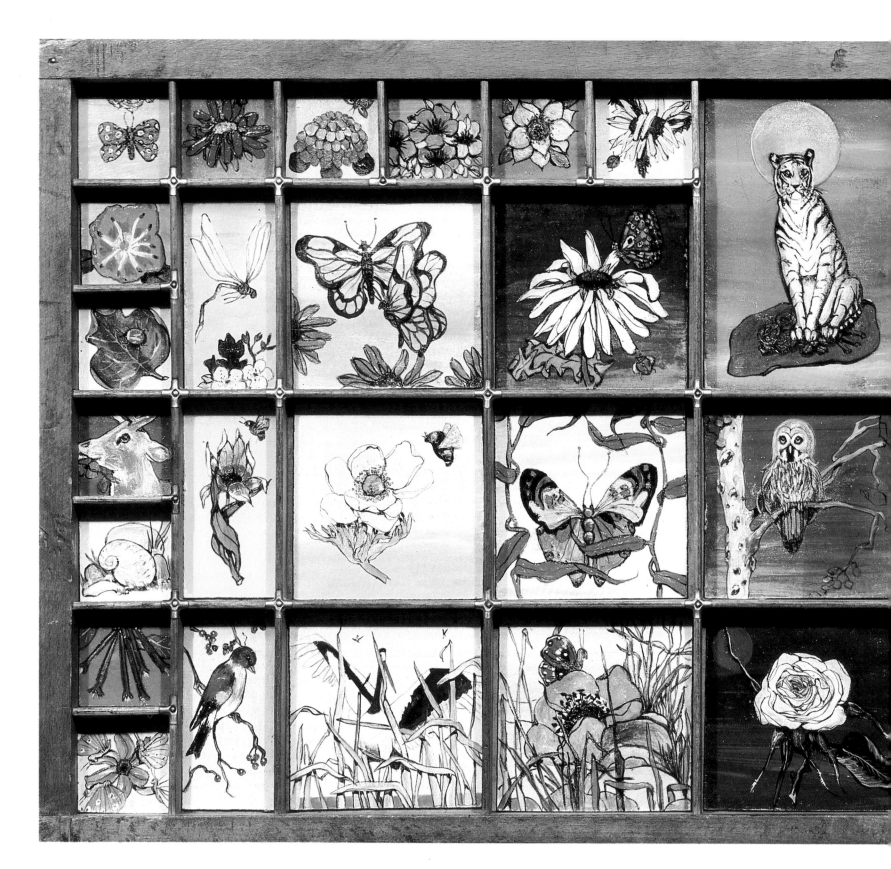

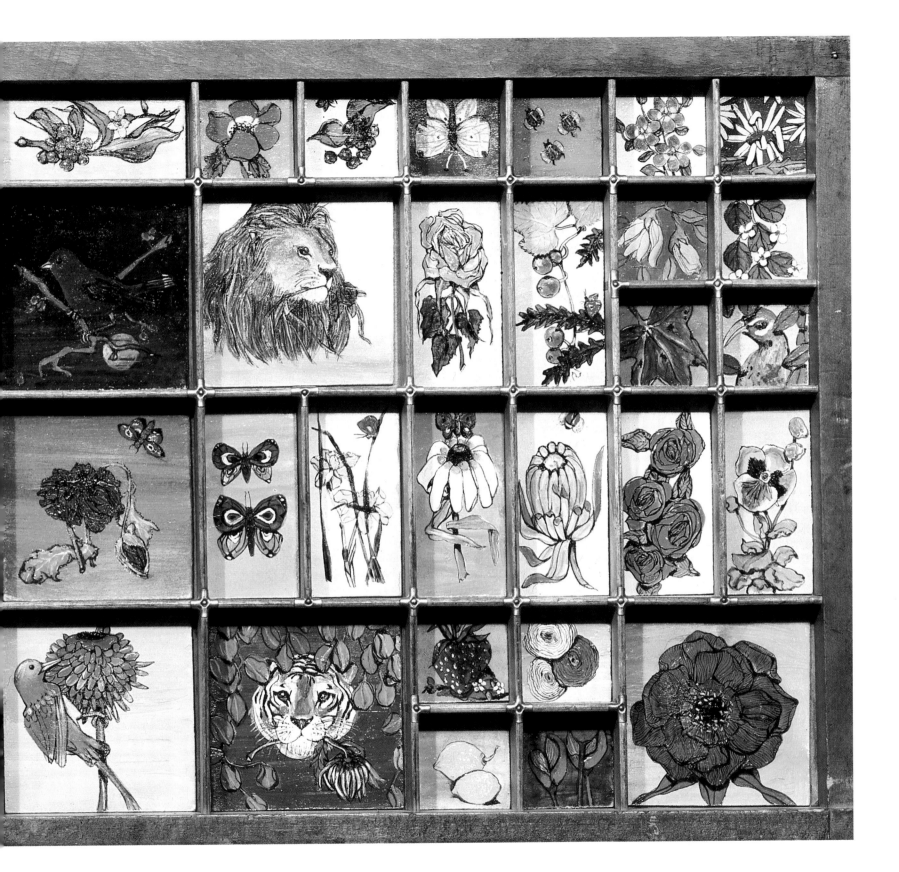

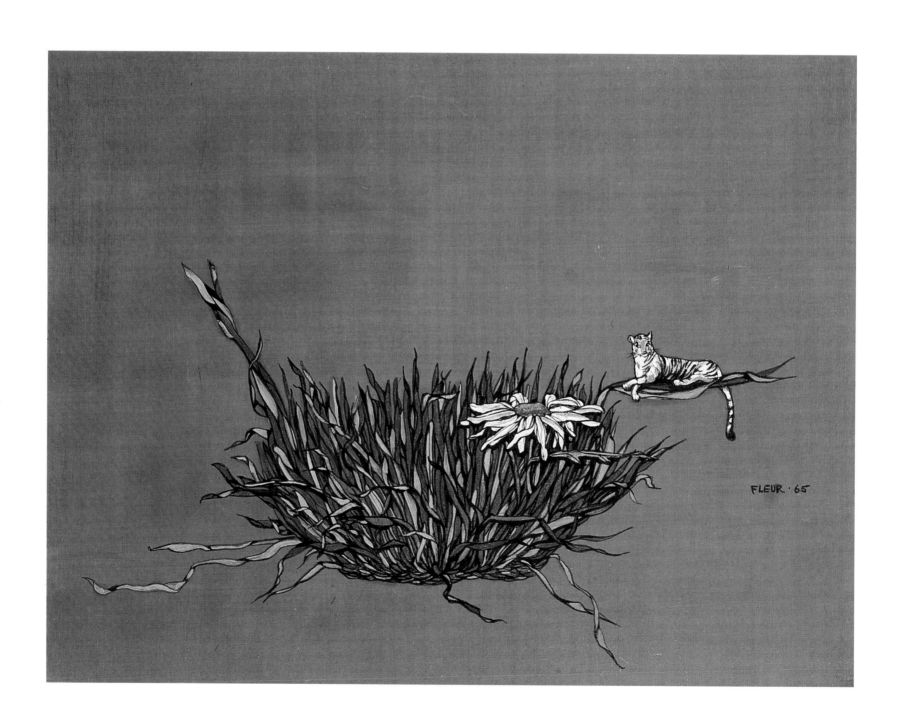

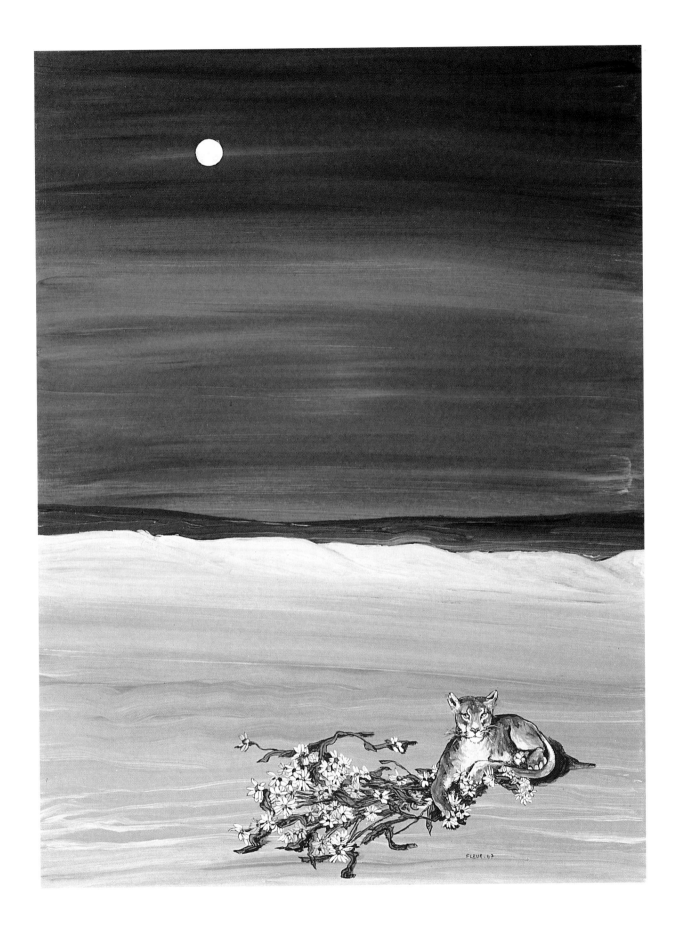

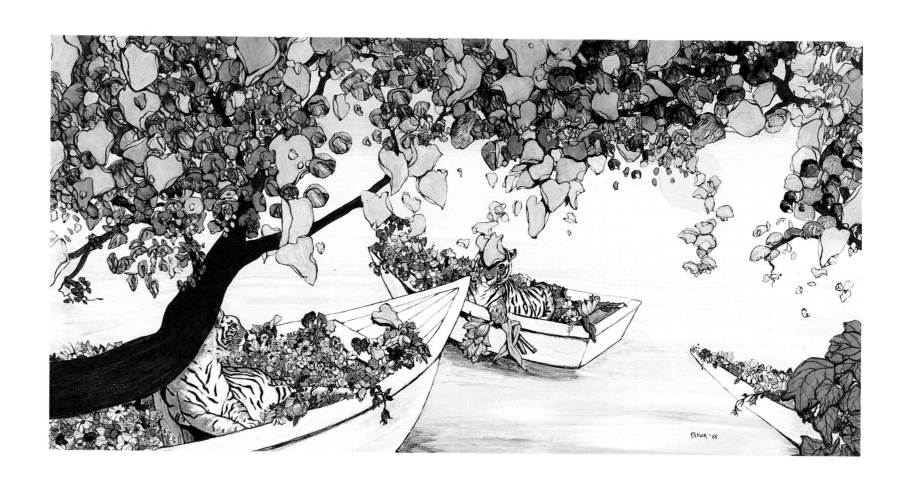

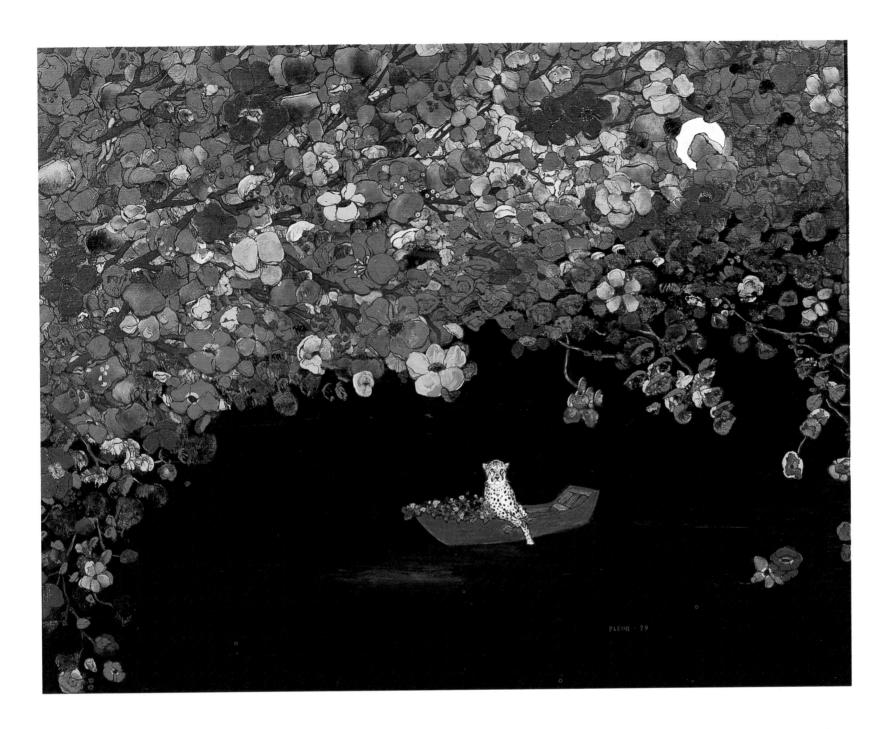

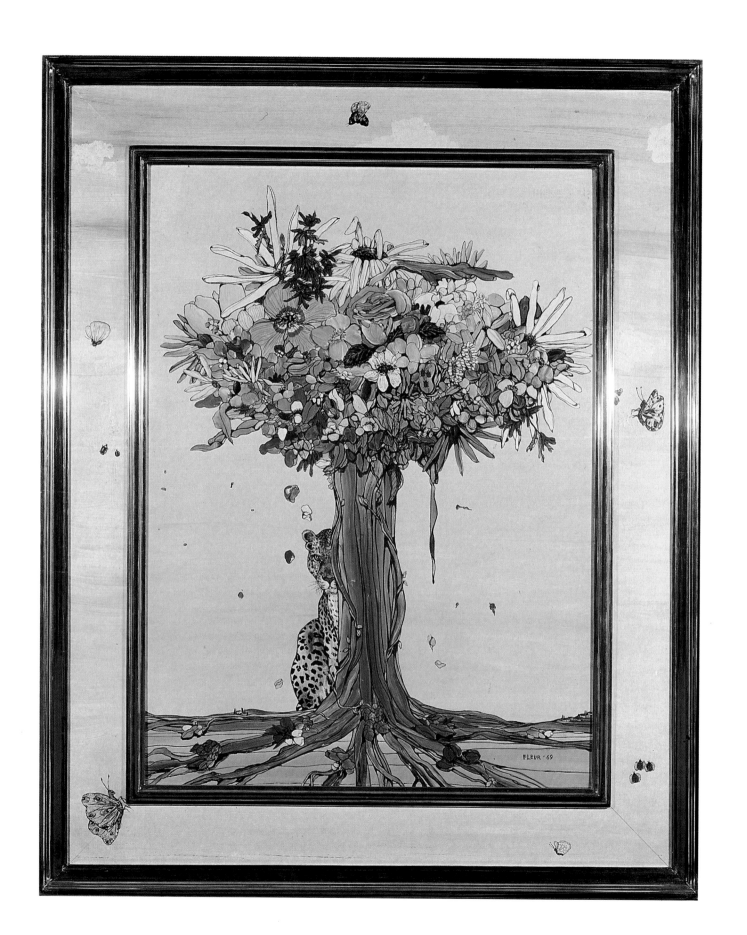

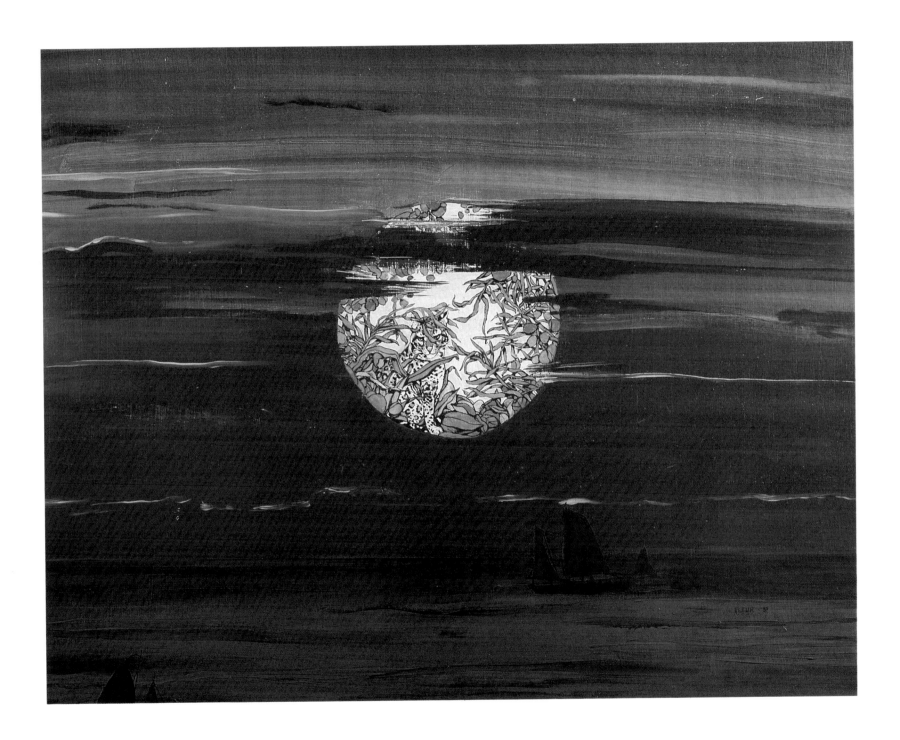

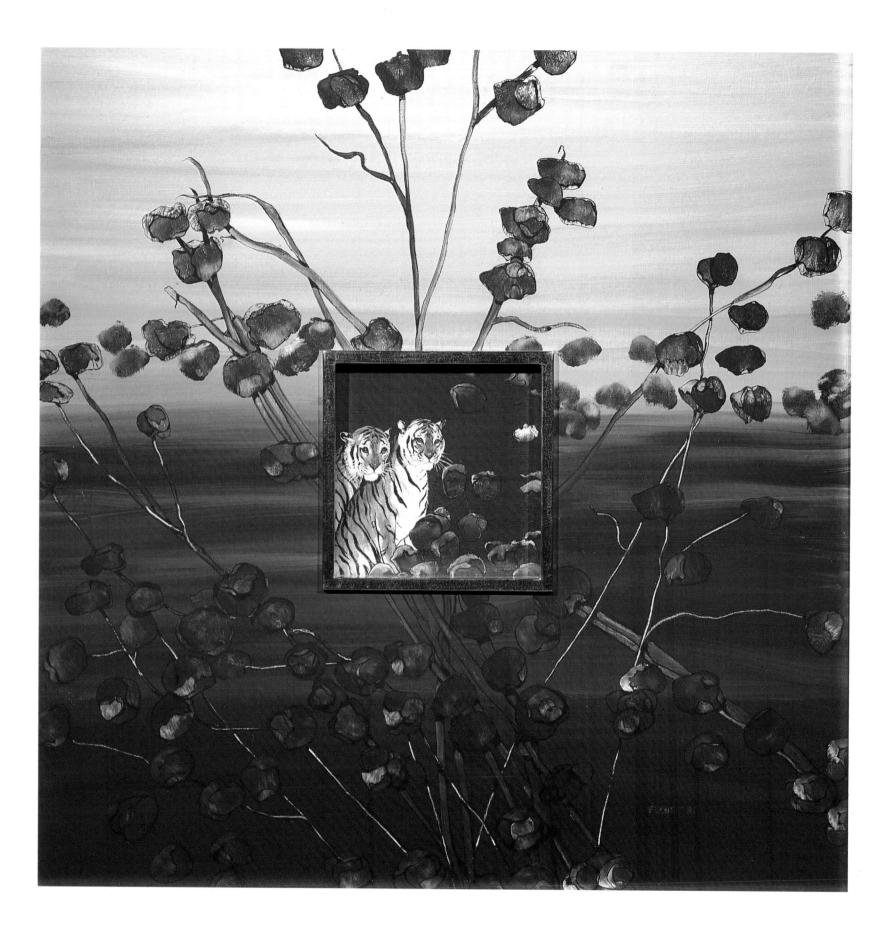

'Beached' (cover): 'A jungle cat in a flower-filled sailing boat. And why not? I like to put my animals in 'human' situations and this proved to be a painting I could have sold to eight or nine collectors.

'Tree of Life' (opposite title page): 'Why shouldn't an elephant or a hippopotamus perch in a tree of life?'

'The Flower Garden' (half-title page): 'This painting formed the basis for the design of my collection of tableware for Limoges in France. Each plate, bowl, saucer, whatever, reproduces a different portion of the same painting; a table set with these dishes is transformed into a garden.'

'Jungle Sunset' and 'Study in Browns' (p. 125): 'These are two good examples of the startlingly different effects I can realize with "window" paintings, simply by radically altering the colour of my palette.'

'Meeting Place': 'I like painting animals in boats and made a meeting place of one for two tigers. Princess Grace of Monaco loved it – it hangs in the palace today.'

'The Owls': 'My first three-panel painting of owls whose shape, face and texture have always fascinated me.'

'Evening': 'I've always been impressed by the beauty of pale sunsets in hot countries. Their serenity and peacefulness must also have appealed to my jaguar.'

'Sunrise': 'Two tigers await the day in the pale light of early dawn in Africa. I found it interesting to paint with such a subdued palette.'

'Afloat': 'Once a friend brought me, all the way from California, a lichen-covered bark taken carefully from a tree; lilies-of-the-valley were tucked in the opening. I later painted it in mystical flight, festooned with birds and butterflies.'

'The Rose that Grows': 'I love roses so much I try to visualize them as trees. This is one of a number I have painted.'

'Life in Tarim': 'After my return many years ago from the 600-mile-long Hadhramoutt desert, south of Saudi Arabia leading to Muscat, this was the first painting I did. I had been the first American woman to be allowed in the "hidden" Hadhramoutt, which is, today, bustling with oil producers.'

'Harvest Night': 'The idea of creating "window" paintings came to me in the early 70s and this two-dimensional example is the first one I painted and now hangs over a mantel in Spain.'

'Trujillo': 'From the top of the hill on which my castle stands in Spain, I can see the bell tower of a former convent. Storks do nest there, but I thought I should suspend the belfry on craggy rocks floating in the air.'

'Daisy Jungle': 'The daisy has natural friends in butterflies and birds, but I decided to add a jaguar to mine.'

'Cyclamen' and 'White Poppy': 'With "Cyclamen" and "White Poppy" I designed hexagonal paintings on dark backgrounds to make a very formal effect, using two favourite flowers. Naturally, a tiger and a cheetah each found its way on to a petal.'

'Magic Mushrooms': 'London's Arthur Jeffress was the first man to persuade me to have an exhibition. These mushrooms were painted for that occasion. The painting belonged to a Brazilian ambassador.'

'Giant Tulip in Basket': 'In my series of oversize tulips (first done for a real *aficionada*, Mrs James Linn), I have tried, by exaggeration, to prove the wonderful beauty of tulips. Two tigers seem to agree.'

'Kashmir Journey': 'A Santa Barbara house is the home of collectors who have eleven of my paintings. This screen covers one vast wall in one room.'

'Surrealist Dream': 'As I note in the text, I once made a speech at Durham University for the opening of their Surrealist exhibition. This painting was hung there alongside works by Salvador Dali, Magritte, Max Ernst and Delvaux, and I was proud.'

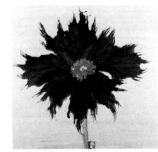

'If Winter Comes': 'Blackbirds, painted from memory in Sussex and hung in my home in Spain, came to life as the real birds living where I do, in the Extremadura.'

'Evening Illusion': 'I tried to dramatize the fearful loneliness of a savannah by painting the tiger in a vivid red block of colour.'

'Golden Couple': 'I painted this mythic pair for the book *To Be A Unicorn*; its parable was written by Robert Vavra.'

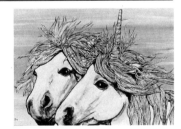

'Tiger Blue': 'I like to work in this palette and the owner of the painting confirms how restful it is to look at in her collection.'

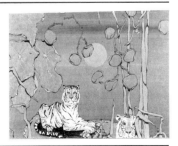

'Poppy World': 'Before it was shipped to Tokyo for the Japanese exhibition of my work, this painting stood against the wall in my office for some months. Everyone who saw it thought it one of the best I'd ever done, and I hope they're right because I spent weeks working on the flimsy petalled poppies, my favourite flowers, and hiding the animals in unexpected places.'

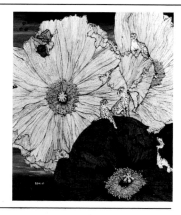

'Marguerite' and 'Chrysanthemum': 'These two facing paintings were in a continuing series of giant flower heads. Both are populated by animals, birds, butterflies and bees, the world in which all live peaceably together.'

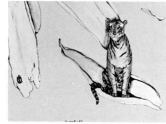

'This "Golden Unicorn" now hangs in the Palace of HRH Prince Huo, son of the Emperor of Japan – a rare honour for a Western painter.'

'Rock Garden': 'I painted this for my exhibition this year in Tokyo, with a bow to their known love for flowers, stones and rocks.'

'In Love': 'A dark brooding night seemed to me the right place to set a cheetah in love waiting for its mate.'

'River Rendezvous': 'I vividly remembered a babbling brook I saw in Scotland and decided to make it a fabulous rendezvous point.'

'Pinnacle': 'This is a gift I gave to the International World Wildlife Fund in Switzerland where something strong and heroic was wanted.'

'"Faraway" is quite like another painting of mine I see, with a pang, prominently placed on the piano in the drawing room of HM Queen Elizabeth The Queen Mother at Clarence House.'

'Bird in Flight': 'This painting was commissioned by a pop singer for use as an album cover, but when it was finished, his agent asked me how much I would pay for the privilege and I showed him the door.'

'Spring Garden': 'I'm happy to find this painting hanging amid very beautiful ones by great masters in the home of a Washington friend.'

'Limbo': 'An exercise in using umber and white, but then I changed my mind and painted the rose in brilliant melon, which I think enhances the final image.'

'Red World': 'To satisfy a crestfallen member of my staff in Sussex, who was saddened by the departure of this painting for an exhibition in America, I made a second version to hang appropriately on the dark brown walls of one room where all the furniture is covered in red linen.'

'Jenny's Nest': 'An astonished guest in Sussex cut this hydrangea in my garden; it is the only painting I've copied from life, so fascinated was I to find a wren's nest so cleverly woven into the flower. What an astute bird it was.'

'View from the Ranch': 'This species of cactus grows in my Moorish garden in Spain. I removed one to a canvas desert and added a very contented tiger.'

'National Monument': 'This splendid elephant was commissioned by the actor, James Stewart, after he and his wife, Gloria, returned from one of their regular trips to Africa. Kenya, the elephant's homeland, had named him a "National Monument". We three pray he hasn't already been slaughtered for his tusks.'

'Rock Garden': 'This represents one panel of a triptych. I painted it with the memory of planting this moonflower in my garden in Spain still fresh in my mind.'

'Nature': 'In this instance, my canvas was an antique, wooden printer's tray. Where type might have been, I've filled the spaces with fifty-three paintings representing almost everything I know about nature.'

'Blade of Grass': 'As well as a painting, this is a precursor of the Scottish porcelain company's production of my figurines and flowers, which are now sold in limited editions throughout the world.'

'Jilted': 'Very rarely have I been found in a sad mood, but I must have been when I painted this brooding animal.'

'Rendezvous': 'I can think of no more charming meeting place than under sunlit trees on the water's edge in boats.'

'Moonlit': 'This painting, surely one of my best, is one of countless bought by a favourite collector who has many. It hangs alone on dark green walls, the moon is spotlit from the ceiling. The effect is extraordinarily haunting.'

'Summit': 'I have frequently composed full-blown flower trees where animals want to claim a place. Around this composition is one of my many painted frames.'

'Mirage': 'What I wanted to do and what I think I've accomplished is to set the animal comfortably on the moon over a brilliant sea.'

'Study in Browns': 'See combined caption with "Jungle Sunset" (p. 122).'

INDEX